Understanding Composition
The Complete Photographer's Guide

Understanding Composition
The Complete Photographer's Guide

#

STEVE MULLIGAN

photographers'
pip
institute press

First edition published in 2008 by
PHOTOGRAPHERS' INSTITUTE PRESS
Castle Place, 166 High Street,
Lewes, East Sussex BN7 1XU

ISBN 978-1-86108-534-4

Associate Book Publisher: Jonathan Bailey
Production Manager: Jim Bulley
Managing Editor: Gerrie Purcell
Editor: Mark Bentley
Managing Art Editor: Gilda Pacitti
Designer: James Hollywell

All photographs are by Steve Mulligan, except on pages 150–153
by Chris Conrad and the author picture on the cover, which is by
Vicki Gigliotti. The darkroom collages on pages 112–113 are by Bill
Godschalx. Thanks to Canon and Nikon for product images.

Colour origination by GMC Reprographics
Printed and bound in China by Colourprint Offset

ACKNOWLEDGEMENTS
Thanks to Chris Conrad, both for his fine digital portfolio and his
advice for the digital section of this book. A grateful thank you to
Tom Till as well, also for his digital advice and tips. Kudos to my
editor Mark Bentley, whose patience and enthusiasm made this
project a relatively painless endeavour. Thanks are due to James
Beattie for his strong advocacy concerning this project. At the risk of
constantly repeating myself, all things are possible because of family.
Much love to my wife Vicki Gigliotti and daughter Alyssa.

Dedication
This book is dedicated to Barbara Lee, the only member of
the 2001 U.S. Congress who voted against the Iraq war.

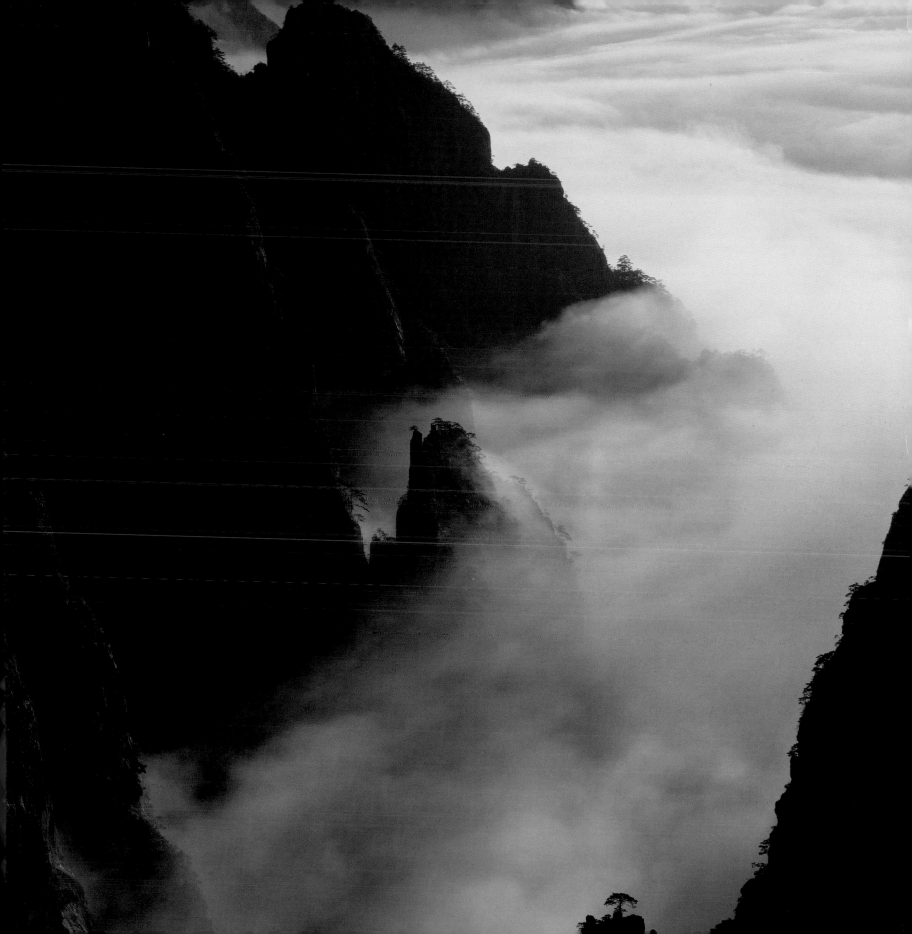

Contents

PHOTOGRAPHY INVOLVES THE SUCCESSFUL combination of myriad elements, all of which bear some weight in the end result of a fine image. Of these multiple aspects, none is as important as composition. No matter how technically perfect, no matter how exciting the subject matter, no matter the colour brightness, all of these elements will fall away if the picture is poorly composed. A jittery and jumbled image is difficult to look at, while a bland and simple arrangement will be boring, leaving little for the imagination to work with.

There is a certain mystique about photographic composition and critics have bestowed a panache on select photographers, declaring them to possess a genius in their craft. While it is accurate to say that some photographers have an innate compositional ability, this is a trait that may be learned, one that any person possessed of a certain sympathy and intuition may develop.

Composition covers a broad range, and this spectrum will apply to any style of photography. Running the gamut from pure abstractionism over to complete and often harsh realism – and exploring a whole range of approaches found between these two extremes – this book will delve into all possibilities.

During my formative years in photography, a famous West Coast photographer came to an exhibition of mine and walked down the row of photos uttering the occasional and indecipherable grunt. After studying the show, he turned to me and declared that my sense of composition was lacking coherence. Picking certain photos for criticism, he politely ripped apart the work. After he left the gallery, a strong sense of dejection washed through me. This was my passion, these prints were the best work I had produced to date, and this noted photographer had obviously decided that my work displayed little or no promise. After surviving the initial shock (to be honest, I had expected praise), and after mulling over his reaction for several days, I decided that he was viewing the photos through his West Coast perceptions. At the time, there was a powerful group of photographers based in northern California, and they adhered to a rigid school of thought when it came to black and white.

While I was familiar with their philosophy, my own work had long since gone on a divergent path, and had been affected by many different influences. With hindsight, my belief is that his reaction was caused, in large part, by the fact that I was not following their approach.

Since that depressing episode, many of the photos that he dissected have been published, both in books and magazines, and several print editions have sold out. The very rules that he decided were being broken are the reason that I like the images, and this was an early indicator of where my own personal vision was heading. Looking back over the ensuing years, this obstinate refusal to submit to any one school of thought is a source of pride for me.

My passion had always been black and white, but as time passed I began noticing an occasional colour scene, and began carrying a few sheets of colour film in my backpack. As my collection of colour transparencies grew, they began to generate sales, quickly outstripping the black and whites in terms of earnings. The colour stock eventually allowed me to quit my day job, which was a great development. While the monochromatic work remains my favourite, I am proud of the colour and pleased that it attracted my attention.

Everyone has their own visual philosophy, a personal view of the world that surrounds them. By approaching familiar or unknown subjects with an open mind, and with thought and practice, this easily translates into compositional ability. This book will hopefully help readers understand and develop their own vision, and will make approachable the forbidding subject of quality as it applies to photographic composition.

Introduction

**One:
Equipment**

\#

Cameras. Lenses. Tripods. Accessories.

COMPOSITION, IN ESSENCE, IS THE SELECTION or rejection of various elements being considered in a photograph. While a certain amount of this process is intuitive, and while it is always a mistake in photography to focus too much on equipment, the fact is that photography relies heavily on cameras and the ancillary support gear. Without some equipment – be it rudimentary or advanced, film or digital – photography as we know it would not exist today.

Cameras and Formats

Image size varies from the smallest digital file up to gigantic view cameras, but the format is all that matters as far as composition is concerned. By working within whatever framework is offered by any given camera, and by adjusting your vision to that shape, successful composition is always accessible.

The most common image size offered with today's cameras is a rectangle. The 35mm film camera translates into a classic 5 × 7in print size, an extended rectangular box. Digital 35mm format varies slightly from film, but is essentially also a long rectangle.

When shot in a horizontal position, this format can display compositional strength, allowing the photographer to employ a variety of styles. Tipped to the vertical, the long shape offers an unusual outlook on the world, but one that must be used with care. While some compositional techniques will be effective in the vertical, the various elements being photographed must be arranged with care.

The square is a common shape, generally offered in medium-format cameras. Many standard techniques will not work in this framing, but the square does offer its own charm and possibilities. Arranging colours and forms within this boundary can be challenging but there will be certain compositions that work well.

There are several medium-format cameras that offer a shortened rectangle, ranging from a 6 × 4.5cm through to 6 × 7cm and up to 6 × 9cm. All of these formats are eminently workable.

The standard view camera is 4 × 5in, and this format gives a short rectangle, enlarging up to the classic 8 × 10in print. This size lies between the longer rectangle of 35mm and the full square. This is a strong format, allowing access to many compositional styles and techniques, working equally well in either the horizontal or the vertical. Larger view cameras come in various formats, with the 8 × 10in having the exact proportions as a 4 × 5. The 5 × 7in gives approximately the same proportions as 35mm.

Panoramic cameras come in different formats as well, ranging from medium-format (usually in the 6 × 17cm size) up to banquet cameras, using the large-format size in an extended version. This may be the most difficult format as far as composition is concerned, but may be used to great effect in the proper circumstances.

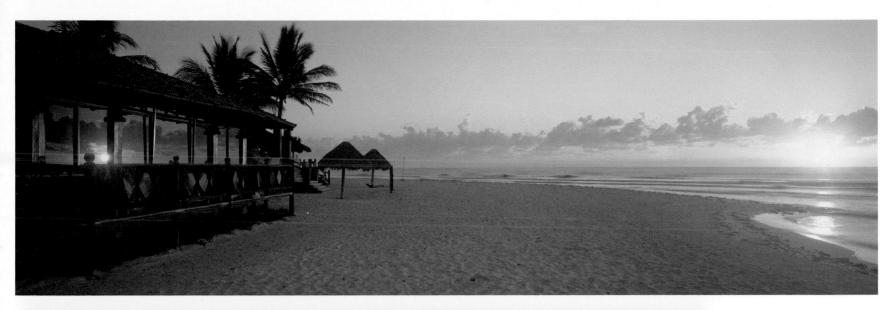

Dawn at Lafittes, Quintana Roo, Mexico
This is a panoramic, taken with a Fuji 617, a medium-format panoramic camera. This framing requires a certain scene to work well, and this particular image fits the bill. The rising sun and its reflection in the window could only have been taken with this format.

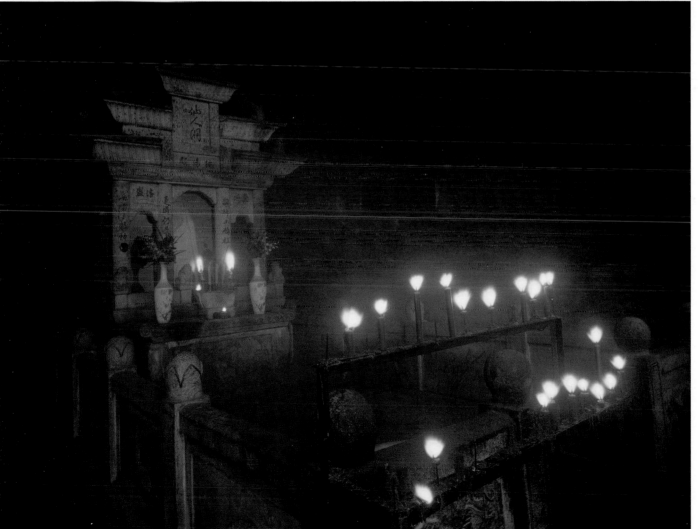

Daoist Temple, Lu Shan, China
This was taken with a 4 × 5, a camera that gives a shortened rectangular shape and that works well with extreme low-level light situations. This was a 10-minute exposure and the only illumination was the candles.

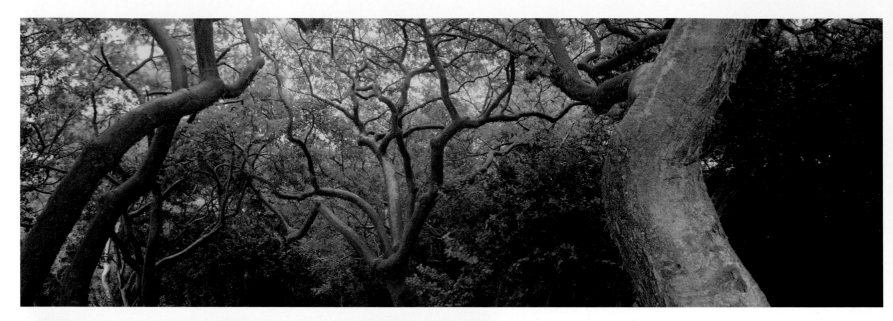

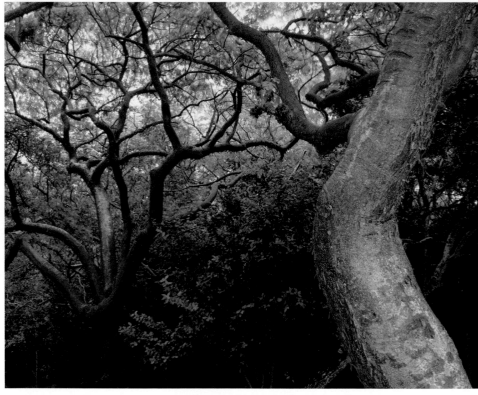

Gumbo Limbo Trees, Long Key,
Florida

COMPARE SHOTS

Every scene requires unique framing, and each possibility has one format that will work best. While an interesting composition may be flexible enough to fit with several format shapes, there will always be one that works best for it.

During a trip to the Florida Keys, a string of low islands that arc away from the tip of the Orange State, I visited a small state park. This grove of gumbo limbo trees caught my eye, and I set up a shot with the 4 × 5. A foreground trunk had a nice curve, and I always watch for this type of design element. Placing the trunk in the foreground right, and filling out the frame with a background tree, I made several exposures. Having hauled my Fuji 617 panoramic camera on this trip, I was determined to shoot some film with it. Using the same basic composition, I simply included one more tree in the left quadrant and exposed one frame. Panoramics are a finicky format to work with, but this scene filled out the long horizontal quite well.

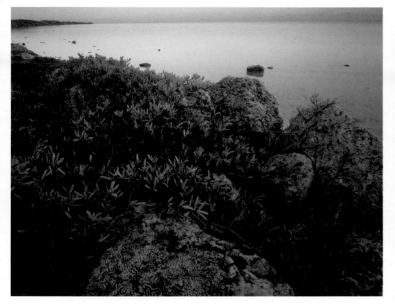

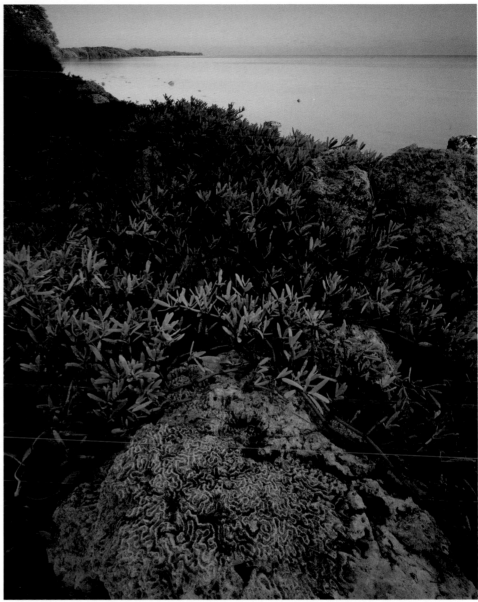

The initial composition that caught my eye, however, is a much stronger photograph, as the trunk balances against the other tree, and the short rectangle is perfect for the multiple elements within this composition.

During my visit to Long Key, I noticed this dead coral slowly being covered by ice plant (pictured above and right). Using a large piece of coral as the foreground, I set up a vertical shot, taking advantage of the small bay and glowing sky. After exposing several sheets of film, I flipped the camera back and composed a horizontal with the same piece of coral.

The second photo is decent enough, and in the stock business, horizontals sell far more often than verticals. The first photo, however, with the large white coral filling the base of the image, is a better composition. By moving in on the coral, the swirls are exaggerated and the overall design is cleaner. The horizontal is somewhat busy, giving too many conflicting points of interest to the viewer.

Coral and Ice Plant, Long Key, Florida

View Cameras

View cameras, which include all sizes from 4 × 5in up to 11 × 14in (and occasionally even larger), are a tool that requires an introspective approach. In addition to the large size – which translates into a sharp, high-quality negative – they offer various movements that control perspective and enhance depth of field.

The image is upside-down, as view camera lenses (unlike smaller format cameras) don't correct this, and camera optics naturally flip the scene. At first, this can be quite disconcerting, but with experience it becomes unnoticeable. The rear element of the camera is where the film holder is inserted, sliding behind the ground glass and held in place by tension clips. The film holders are a rectangular plastic device, with one sheet of film on each side, protected from light by thin dark slides. These slides come out during exposure and save the film from being fogged. After exposing one side, the film holder is flipped, allowing the opposite sheet of film to be used. Sheet film must be loaded in the dark, with the film notches in the upper right hand corner to ensure the emulsion side is facing up in the holder.

The bellows is the middle part and is an accordion of supple, lightproof material designed to connect the rear element with the front. The front element is designed

My 4 × 5 Toyo Field View camera.

to hold the lens and with field cameras it allows for focus through its movable track. The amount of bellows stretch is determined by the focal length of the lens: a wide-angle will cause the bellows to compress, while a telephoto will require it to expand.

The rear tilt element of the camera is one of the best features these cameras offer, as it can give an astounding depth of field. By focusing on infinity, and combining the backward tilt with a small aperture, depth of field becomes virtually limitless. This is done by leaving the front element on the same angle and then tilting the rear element back. By then closing down the aperture the entire scene will be made sharp.

While this technique will work best with wide-angle lenses, it can be employed with any lens. As the focal length of the lens increases, the allowable tilt decreases, but it can still be used to a minimal degree. This technique will work particularly well for extreme near–far compositions but will help any time a depth of field enhancement is required.

The larger cameras, 5 × 7 and up, are too cumbersome for long hikes. Their size and weight will limit their use to short walks or studio work.

While these cameras have some advantages, a 4 × 5 will satisfy most view-camera needs. I have worked with both 5 × 7 and 8 × 10, but always came back to 4 × 5. The larger cameras will generally limit the photographer to making unenlarged contact prints (where the negative is laid directly on the photo paper), and this eliminates many of the controls available in printing.

View-camera lenses are fairly simple pieces of equipment, and they come in many focal lengths. A 150mm is considered normal, a 90mm is a moderate wide-angle, and a 210mm is a medium telephoto. These lenses come with a shutter which has a simple combination of speeds and apertures. Both lens and shutter are mounted on a lens board which locks into the front element of the view camera.

Also required is a dark cloth, which is simply a large rectangle of black cloth. This is draped over your head and the ground glass to facilitate focusing. These come in several styles and mine is black on one side and white on the other, which keeps my head cool while focusing on hot days.

Shop Around
There are many different view cameras available and, as with most equipment, there is no real reason to buy a new model. If the bellows are lightproof and the rest of the camera seems to be tight, it should be a workable camera. There are many reputable equipment dealers and I have always been satisfied with my purchases of used gear.

Medium-Format Cameras

Medium-format cameras offer many incentives, as they give a reasonably large negative size without the bulk and weight of a view camera. There are several sizes available, ranging from 6 × 4.5cm up to 6 × 9cm. My first medium-format camera was a 6 × 6cm Yashica Mat and I bought it at a flea market for a pittance. This was a fun and reliable twin-lens reflex camera and it withstood several years of rough treatment.

From there, I moved up to a Hasselblad, which is a fine camera, but is much more costly. The Hasselblad optics may be the sharpest available on the market, and I used this camera for years, finally becoming frustrated with the square format (I tend to see in rectangles as a rule), and selling it. These days, I use a pair of Pentax 67s, mostly for aerial work. These are workhorse cameras and, being SLRs, are perfect for the unusual demands of shooting from a small, fast-moving plane. SLR stands for single-lens reflex, meaning that the viewfinder shows, through a mirror that lifts during exposure, what the lens is transmitting to the film plane. Most medium-format and 35mm cameras are SLRs. Another type of camera is the rangefinder, where the viewfinder displays a separate view from the lens, giving a close approximation of what will end up on the film. Most of these cameras have a parallax correction, which mimimizes the discrepancy between the viewfinder and the picture-taking lens.

This size is a nice compromise between large format and 35mm, offering a larger negative, but with the film still coming in rolls, making development much easier and giving multiple exposures. These cameras are versatile, equally usable on a tripod or for hand-held work. The newer medium-format cameras are more compact, making them even more attractive and easy to use. The Mamiya 645 is a good camera with decent optics and is almost as easy to handle as a 35mm.

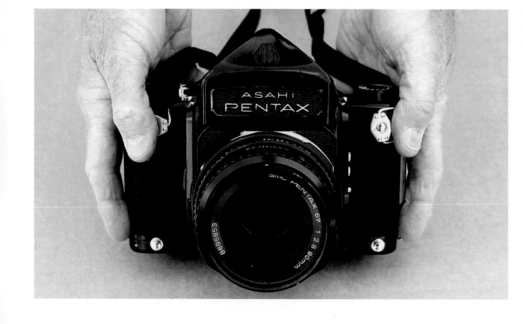

Workhorse camera
A Pentax 67 medium-format camera.

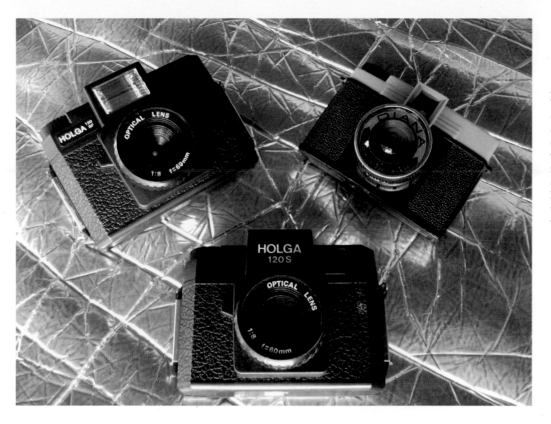

Plastic Cameras
These are my three plastic cameras: a Diana (which is, amazingly enough, 30 years old and still working), a Holga with a built-in flash and a regular Holga. These cameras are incredible fun and there has been recent interest in the portfolio I have created with them.

In Praise of Plastic Cameras

In my third year in college, on a whim, I bought a 99 cent toy plastic camera called a Diana. Everything on the Diana is cheap plastic, including the lens, which creates an interesting distortion. Over the years, I have used this camera for catching the occasional odd scene, and for helping break a photographic block. There have been several times when I just wasn't able to take a decent photo, and the frustration can be unbearable. Whenever that happens, I put my main cameras in the closet, and just shoot with the Diana. This has broken more than one visual barrier for me, as the toy camera forces a certain freedom and relaxation. It is hard to be serious when your camera lens is melted from sitting on a car dashboard and you can hear the film peeling off as it is advanced. Perusing Dianas on the internet recently, I was shocked at the prices they command. Refusing to pay $60, I ordered a different toy camera.

The Holga is similar to the Diana, but seems to be of higher quality, which is not a good thing when it comes to toy cameras. This problem was quickly alleviated with a small piece of sandpaper and some petroleum jelly. Sanding the edges of the lens and then smearing it with a light coat of the jelly seemed to solve the problem of superior quality, making the Holga a fun camera to use. It also has the advantage of a built-in flash, a fun feature that I have been using for fill-in illumination.

I recently published a limited edition book that featured my plastic camera photos and my daughter's poetry. *Darktown* sold out quickly and my 15-year-old daughter received her first royalty cheques, which were quite a hit. These cameras are unmitigated fun, and they offer an important counterbalance to my view-camera work.

35mm Cameras

For street photography and photojournalism, as well as for general ease of handling, the 35mm camera is superb. These cameras are light and unobtrusive, and very easy to work with. There are so many styles of camera available that it can be a confusing choice. However, the best philosophy is to keep everything as simple as possible. Too many bells and whistles will draw attention away from your main objective and are simply a distraction.

Bought when I was 15, my first 35mm camera was a Petri, outfitted with a 50mm lens and a basic match-needle meter. This type of meter has a fixed circle and a moving needle, and when the needle is centred on the circle the exposure is read as correct. My next

35mm was an Olympus OM-1, it was smaller and easier to use than the Petri and also had a simple match-needle meter. I always kept a 28mm lens on it and this moderate wide-angle was perfect for grab shots.

The 35mm can be used for most styles of photography, from photojournalism to landscape. Using a tripod and smaller apertures will render surprisingly sharp negatives. While the larger cameras will give higher definition with big enlargements, smaller prints give a nice feeling of intimacy and can draw the viewer into the scene. Larger blow-ups from 35mm can also be interesting and the extreme graininess that occurs with faster film can give a different perspective.

Digital SLRs
Cameras such as these are extremely versatile.

Cameras with a spot-metering option work very well with the Zone System, but any meter, within the camera or not, will work for this methodology. A fully automatic metering system will not work, however, as there needs to be more control than this type of meter offers. This is rarely a problem, as most modern 35mms offer some variation of a shutter or aperture priority metering system.

As with the larger formats, there is a huge variety of lenses available for 35mms, but a small and simple selection will work best. A normal (50mm) will always be a mainstay, and a wide-angle (28mm or 24mm) is an important component. A mild telephoto will occasionally be needed, perhaps a 200mm. There are several types of zooms available, but third party lenses, in my experience, tend to be of a poorer optical quality, so lenses made by the camera manufacturer are recommended. As with most equipment, used lenses will usually be fine.

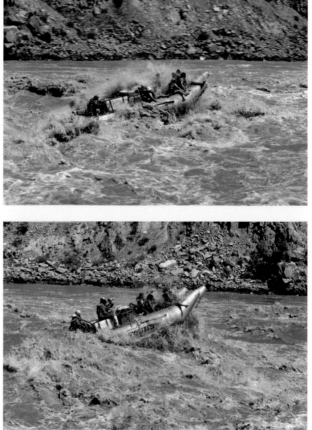

Rafting in Canyonlands, Utah
The 35mm camera gives a huge flexibility to the photographer, allowing a quick reaction to any rapidly unfolding scene. Action photography requires these quick reflexes and the small camera size offers ease of handling.

During my tenure first as a river guide and then as a river ranger in Canyonlands National Park, I spent many hours watching rafts negotiate the large rapids of Cataract Canyon. Spring snow melt in the mountains swells the Colorado River, enlarging the rapids. Big Drop Two has the largest whitewater in this canyon, and this sequence shows a J-rig (a large, motorized white-water raft) running through the largest wave in this rapid. This sequence could only have been taken with a hand-held camera, as it required a panning motion, following the raft as it runs through the rapid.

Lenses

Every format has a standard focal-length lens, and this will be the norm for most photographers. The normal lens for 35mm is a 50mm, for medium format a 90mm, and for 4 × 5 it is 150mm. These lenses will be a starting point, a place to begin the quest for proper framing for any given scene. By moving up to telephotos or down to wide-angles, the best lens for any particular composition will reveal itself.

For every potential composition, there is one focal length that will be best, that will maximize the image possibilities. On occasion, the first lens selected will be the optimal choice, other times a winnowing down will lead to the best lens. Staying open to these possibilities will greatly aid in the composing of a photograph, helping to push past the technical into the intuitive, where excellence is to be found.

Zoom lenses offer a range of focal lengths and are a handy tool. By utilizing the various focal lengths offered, a composition may be fine-tuned, a much easier process than physically changing multiple lenses.

Plastic cameras, also known as toy cameras, offer an unusual approach to photography, as their lenses are usually soft-focus. The imprecision of these cameras gives a certain freedom, forcing the photographer to accept whatever is offered on the final piece of film and paring photography down to pure vision.

Redbud, Pennsylvania
The redbud is a harbinger of spring in the eastern woodlands, always the first plant to bloom and show colour. On a hillside in Pennsylvania, this small redbud was blooming amidst a gaggle of empty tree branches, offering a compositional challenge. As the setting sun backlit the pink blossoms, I feverishly played with different lenses, trying to isolate a composition. Placing a mild telephoto on the view camera, this scene came together. The stark, leafless tree trunk gives a good counterpoint to the illuminated flowers, and this is a very complex composition.

Viewpoint is an inherent part of composition, and the standard method is to change camera location. Another way to alter this, however, is to change the focal length of your lens. Often even a small alteration in focal length will make a huge difference in composition. This can happen either through an actual lens switch or through the use of a variable focal-length lens. By changing a view camera from a 150mm (which is a normal focal length for a 4 × 5) down to a 135mm lens, the framing can be drastically modified. Despite the relatively minor difference between these two lenses, the framing will be noticeably different.

The difference between a wide-angle and a telephoto is obvious, and compositions will be drastically changed. The variance between similar focal length, however, will introduce a subtle change, often morphing a mundane scene into a strong one, cropping out extraneous elements.

In focus
Choice of lens is crucial when deciding on a composition.

COMPARE SHOTS

Albion Basin is in the mountains above Salt Lake City, Utah, near a famous ski resort. Noted for its spring wildflower display, the canyon is also home to myriad wildlife. During this photo shoot, a moose followed me at a distance, carefully watching my every move for more than an hour.

The flowers were profuse and the Devil's Castle provided a fine background. A strong foreground element, however, was lacking. While the wildflowers were beautiful, I wanted something that would lead the eye into the scene. Finding this fallen snag, I decided to incorporate it into the photo. Setting up my 4 × 5, and choosing the 135mm – the lens I most often use with this camera – I composed the image (see version one).

As is my habit, after exposing several sheets of film I checked the ground glass, making sure the camera hadn't shifted during the exposures. The photo was still correctly framed, but I decided there was slightly too much in the composition. The tripod was precariously straddling the log and changing position would have altered the photo, possibly ruining the composition, and so I put a 150mm lens on the camera (see version two). This slight change in focal length made the log a much stronger shape, as well as tightening in on the mountain and cropping out extraneous trees.

When the film arrived from the lab, the tighter shot was better, and I was happy that my double-check caused the reshoot.

Wildflowers, Devil's Castle, Albion Basin, Utah
LEFT **Version one**
RIGHT **Version two**

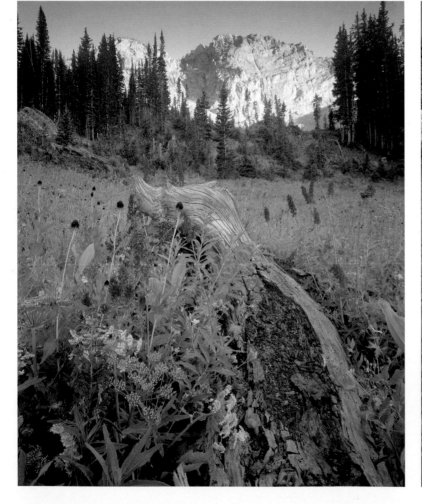 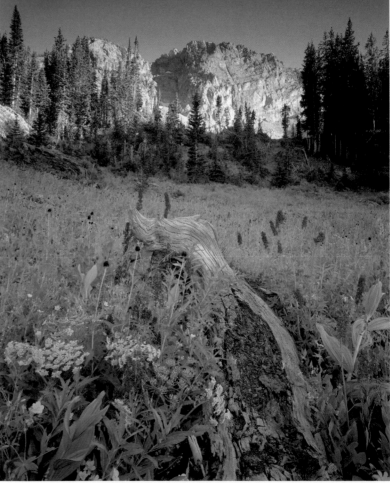

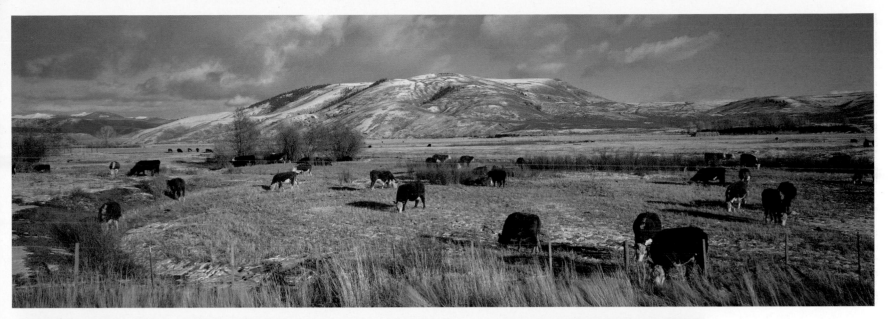

Cattle
Panoramics are not my favourite format, but this scene was perfect for the Fuji 6 × 17. The herd of cattle, low-lying hills and puffy clouds all come together, fitting this framework perfectly, presenting a classic portrait of the American West.

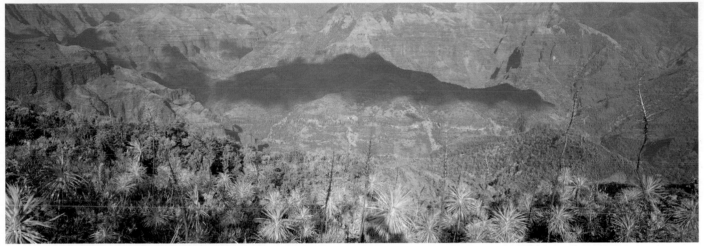

Waimea Canyon, Kauai, Hawaii
Compositional conditions will determine which format will work best for any particular scene, and isolating these elements will help with this decision. On a trip to Kauai, the most photogenic of the Hawaiian Islands, I decided to try a panoramic of the amazing Waimea Canyon. The multiple plants in the foreground give an interesting base to the panoramic, and this layer of shapes helps with the tricky format.

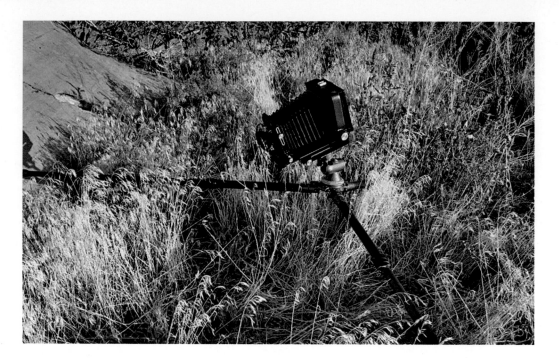

My 4 × 5 and tripod
The Gitzo tripod is set on a low level, with the three legs spread out, allowing for a close-up of the surrounding grasses.

Tripods and Heads

Tripods are an important tool in photography, allowing both long and steady exposures, as well as giving a precise sense of composition. They come in myriad sizes and styles and there is a design for every need and camera.

Long exposures open amazing compositional possibilities, often revealing aspects that are invisible to the naked eye. These are only possible with a tripod, and this support must be solid to avoid any camera vibration during the open shutter time.

To test a tripod's steadiness, open all three legs to eye level, lean your weight down on the head and sharply tap one leg with a fingertip. If the legs vibrate or bow out, the tripod is probably not strong enough. Ultra-light and small tripods are generally shaky and will only work with small cameras.

Carbon fibre tripods are both strong and light, and able to handle almost any situation. While these are expensive, they have a long life and should last for many years of heavy use. Aluminium tripods are also often well made, but tend to be heavier than the carbon fibre, albeit less expensive. Another important feature in a tripod is the ability to lower the head through a design feature that allows the legs to open out sideways. This will let the photographer find almost any angle on a subject and will allow for extreme close-ups as well. By extending only one or two legs sideways, and keeping the others at a normal angle, the camera may be placed in very contorted positions.

The head is that piece of equipment that attaches the camera to the tripod, and these also come in many shapes and forms. One favourite, both for compactness and flexibility, is the ball head. This is essentially a metal ball that floats around in a clamp, allowing a large degree of angle change and many framing options. The other standard design has two handles, one that controls forward and backward tilt, with the second locking down the side-to-side angle. This is also a workable design, but offers less flexibility than the ball head.

Ice, Colorado River, Utah
After a series of hard freezes the Colorado River had formed interesting ice floes and I wanted to take advantage of this rare event. Wanting to blur the river ice, I used a tripod to steady the camera during the long exposure. This type of image is only possible with a tripod to hold the camera still.

Helping out
Tripods can be cumbersome, but can also greatly improve the quality of negatives. By allowing the use of a slower shutter speed and a smaller aperture, depth of field can be greatly extended. Extreme exposures can give interesting results.

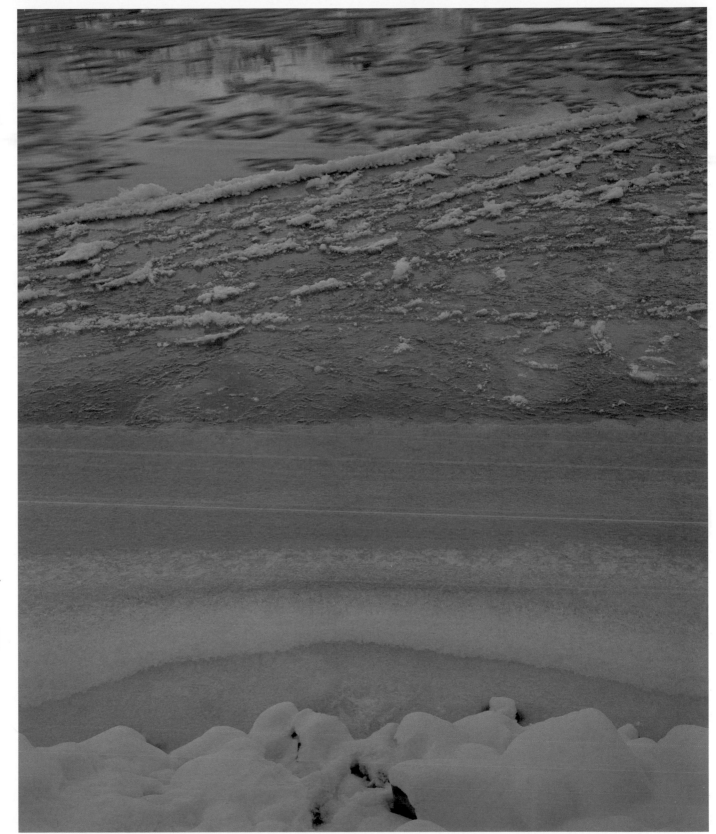

Useful Accessories

As a rule, the simpler the photographic process is kept, the more the creative aspect may be explored. There are, however, some accessories that will be important for technical success.

The cable release is a short length of cable encased in a cloth or plastic sheath, and is necessary when long exposures are contemplated. Pushing the shutter release button by hand will shake the camera, ruining any long exposure. The cable release negates this problem by allowing for a gentle trip on the shutter.

Filters are an often over-used tool in photography, but occasionally are required. Contrast is difficult to control with colour transparency film (and also with certain digital compositions), and a neutral split-density filter becomes a very handy tool. This is usually a piece of optical-grade plastic, with one half being clear and the second half darkened to some degree, anywhere from one f-stop up to three. By placing the darkened half over the brighter part of a composition (usually the sky), the higher tones can be lowered, controlling the contrast in the final image. This is an important tool, giving some measure of control over scenes that are too harsh for film or sensor to handle. There are two techniques used with these filters, the most common being a mounting bracket that holds the neutral-density filter directly in front of the lens. This will work when there is a straight line between the dark and light areas in the scene but will cause uneven density in other compositions. By hand-holding the filter, moving it during the exposure, these uneven density areas will be minimized.

Neutral split-density filters give the photographer a certain amount of contrast control, particularly with colour transparency. This film offers few contrast controls and judicious application of a neutral density will help with this problem. Skies are often the crux of high contrast problems and filtration will bring these densities down.

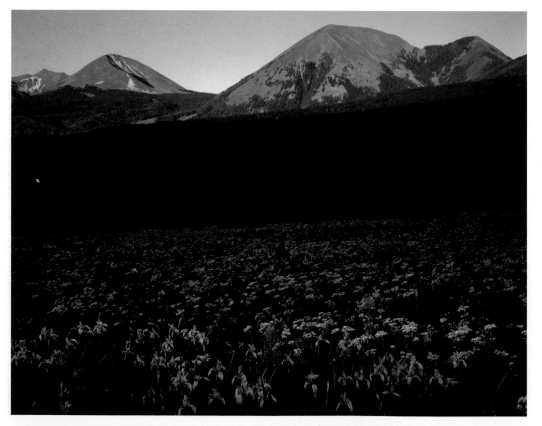

Rocky Mountain Iris,
La Sal Mountains, Utah
This field of flowers made a great foreground, with the mountains completing the composition. The contrast range was huge and a neutral split-density filter was used, darkening the upper part of the scene while holding detail in the wildflowers. This is a classic application of this filter and the photo would have been impossible without it.

Polarizers

Polarizers can be useful, as they darken a clear sky (to a degree which can be controlled by rotating the two layers of the polarizer), but this is a technique that must be carefully applied. Over-use will cause an unattractive contrast, especially if there are clouds in the scene. There are several types of polarizers available, including a warming version that can work well in some situations. As colour film often has a cool cast, a warming filter may be used to counter this shift.

In monochromatic photography a red filter will bring sky densities down dramatically, again a technique that should be applied with care. Other colours have different effects on black and white, usually dropping the tonalities of the opposite colour. Red turns blue dark and yellow drops green tones down. Conversely, the same colour will lighten and a red filter will shift reds towards the higher end of the tonal scale.

Filtration is a handy aid, but must be applied with discretion. These are tools that should improve the final image, but their use should never be obvious in the photograph. As with burning and dodging in black and white printing, as soon as the viewer can discern that it was done, it has failed.

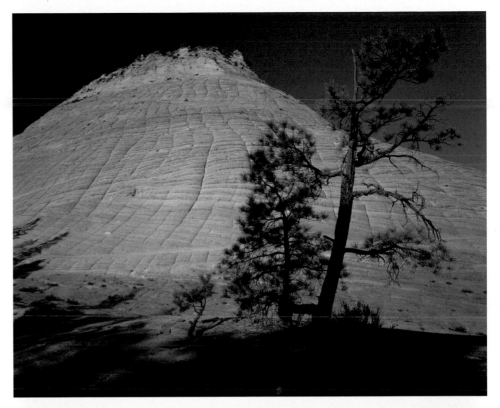

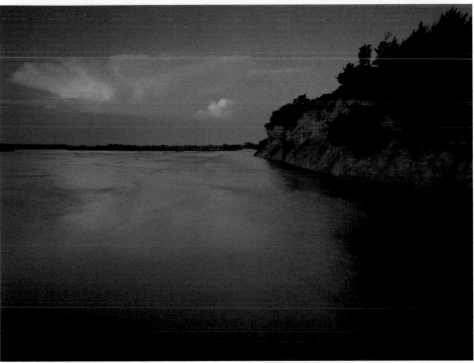

TOP
Checkerboard Mesa, Zion National Park, Utah
Putting this pinyon pine in the right half of the image, I filled the rest of the scene with the mesa. This is a strong composition but I over-used the polarizer and the left side of the sky went far too dark. While polarizers can increase drama in a photograph, they must be used carefully.

RIGHT
Niobrara River, Nebraska
This was taken in pre-dawn light, seconds before sunrise, with a polarizing filter set to minimum polarization. The filter brought the sky density down and the slight increase in contrast has helped this photo, emphasizing the dramatic pink cloud.

The Contents of My Pack

My backpack of choice is a LowePro Super-Trekker, the largest camera pack this company makes. It has a good suspension system, including a padded waist belt, and comes with enough adjustable dividers to fit most camera set-ups. It also has a reliable tripod holder, handy for those times when both hands need to be free, usually when I am desperately grabbing rocks and roots, scrambling up some slippery slope.

A Toyo Field View 4 × 5 is my main camera. It is a very tough and reliable piece of equipment. While on a winter trip with a friend many years ago, I watched his Toyo and tripod topple onto some ice and assumed that our trip was over. To my surprise, he picked it up and kept shooting, an impressive display of camera toughness. Shortly after that trip I bought a Toyo, and it has stood up to ten years of serious abuse.

I carry five lenses, of varying focal lengths:
1) Nikkor 75mm
2) Rodenstock 135mm (my favourite lens)
3) Caltar 150mm (The difference between this and the 135mm is surprising, and there are occasional times when the Rodenstock is slightly too wide.)
4) Nikkor 210mm
5) Wollensack 400mm

My main light meter is a Pentax one-degree spot meter and I carry an averaging meter as a back-up. A dark cloth serves as extra padding over the lenses, and I have a pocket devoted to survival gear, including waterproof matches, a small solar blanket, a compass, several glow sticks (for signalling) and a heavy-duty rain poncho. Fortunately, I have rarely needed any of this gear. Several years ago, however, an unexpected flash flood in a narrow canyon trapped me on a high ledge and this gear was quite helpful during my four-hour isolation.

There are a few filters, including a polarizer, a yellow and a neutral split-density. I carry two small umbrellas in the side pocket, and have often used them to shield the camera during rainy photo sessions.

My tripod is a Gitzo Mountaineer, one of their carbon fibre models. While this is an expensive tripod, it is strong enough for a view camera and still amazingly light. It can also put the Toyo in almost any position, an important feature, as I often cram my camera in ridiculously low and tight places.

Gear in pack
The top layer is film holders, each in a resealable plastic bag. I use these to keep the film clean in the field. The next layer is lenses, also in bags, arranged in order from wide to telephoto. The camera is on the bottom row, as are the 400mm and the spot meter. The various pockets in the front flap contain filters, brushes (to wipe the dark slide before opening the holder), cable releases, a compass, glow sticks, waterproof matches, a small first-aid kit and a solar blanket. Umbrellas and a large poncho are stored in the side pockets.

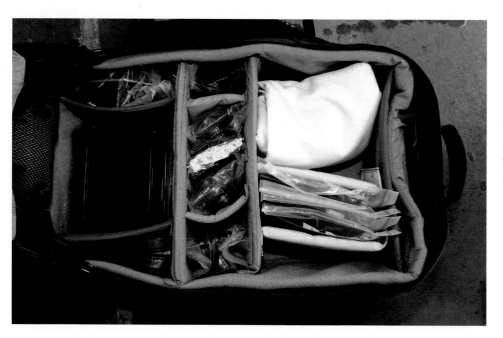

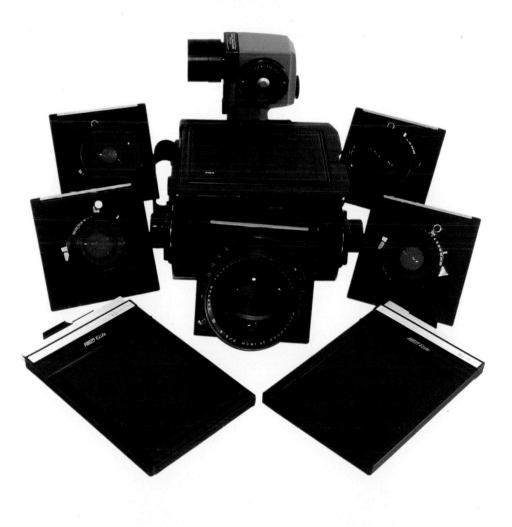

My medium-format case
Two Pentax 67s are in the case, one for black and white and one for colour. The rest of the case is taken up with colour and black and white film.

Top gear
The Toyo is folded up for storage. The various lenses I use are arranged around the camera, as are two film holders.

A Personal Philosophy of Equipment

In the overly technical world we live in there is a plethora of equipment available for any endeavour, and this is particularly true in the field of photography. There are so many cameras available, both digital and traditional, it is a wonder that anyone can decide what brand and format to choose. This confusion is exacerbated by sophisticated advertising campaigns and by the steady infusion of corporate influence into the publishing field. The bottom line is – and always will be – fulfilling personal goals and creating meaningful images. The tools used are unimportant, so long as the photographer is pleased with the final product.

My personal mainstays have remained the same for over a decade, in large part because these cameras continue to work for me, and in equal measure because I am too stubborn to change. My main camera is a Toyo Field 4 × 5, a versatile view camera (albeit on the heavy side), with enough movements to satisfy my needs. I also carry five lenses: a very wide-angle, a less wide one (slightly wider than normal), a normal, a mild telephoto and an extreme telephoto.

The ball head is one option for mounting a camera on the tripod, and this piece of equipment gives more flexibility and angle options than the two-angle handle adjustment system. The photo below shows the 4 × 5 mounted on a ball head, which is connected to my Gitzo tripod.

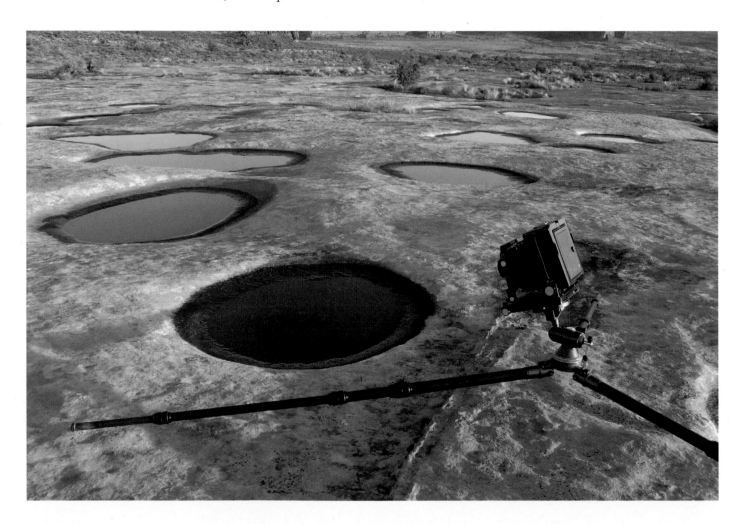

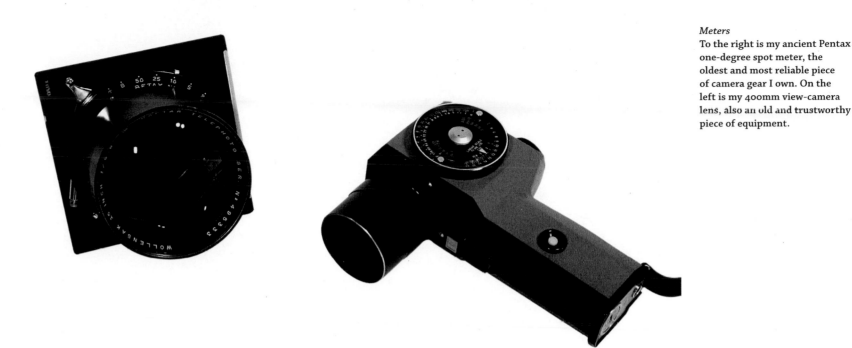

Meters
To the right is my ancient Pentax one-degree spot meter, the oldest and most reliable piece of camera gear I own. On the left is my 400mm view-camera lens, also an old and trustworthy piece of equipment.

I also have a spot-meter, which is used for both black and white (with the Zone System), and for colour (with a modified Zone System technique).

For aerials, I have two Pentax 67s, medium-format cameras that give a 6 × 7cm negative. This camera is essentially a blown-up 35mm, and is perfect for aerials. One is for colour and the other for black and white, as it is impossible to change film in time to catch a scene from a small plane. Both of these cameras have a normal lens and perspective changes are controlled by the plane's altitude.

For sheer fun, I have several toy plastic cameras, all of which take medium-format film. These offer photography in its purest form, with very little machinery between the exposure and the final photograph. This immediacy allows an amazing freedom, offering a free-form approach to composition. In recent years these toys have been garnering attention and I have published a small, limited edition book of my plastic camera photos.

Choose your equipment to fit the type of photography that appeals to you, and when a set-up works, stick with it.

Constant changes in cameras, equipment and film will keep the photographer off-balance, never allowing for a comfort zone to be reached. The perfect camera system is one where the photographer doesn't even need to think, where the equipment intrudes as little as possible between the photographer and the image.

Two:
Basics

Viewpoint. Rule of Thirds. Leading the Eye. Intuition.

Dawn, Konza Prairie, Kansas
Konza Prairie in eastern Kansas
remains a favourite subject of
mine and has occasioned many
visits in different seasons. After
a hard winter storm passed
through the area I drove into the
preserve before dawn, looking
for subject matter. The moon
was setting over this snow-
covered hill and the horizon was
picking up a nice glow from the
east, where the sun was about
to rise. The small tree accented
the moon and the pre-dawn
light was very rich. This is a
symmetrical arrangement,
mainly because of the gentle and
repeating patterns of the hills.

COMPOSITION IS DEFINED AS AN ARRANGEMENT,
structure or mixture. In photographic terms this means
the arrangement of the various elements chosen to fill
a frame, the structure displayed by those elements and
the way in which those various shapes and designs are
mixed together in the final image.

There are innumerable compositional possibilities
located within every scene, with the only true limit
being the photographer's imagination. Success
as defined in photographic composition is an
amorphous thing and quality is found in the eye
of the beholder. There are – despite the seemingly
unlimited possibilities – certain types and techniques
of composition which are reliably effective and a set of
fairly simple rules will aid in choosing what to include
(and what to exclude) within any given image. Intuition
will aid in deciding when to break the rules.

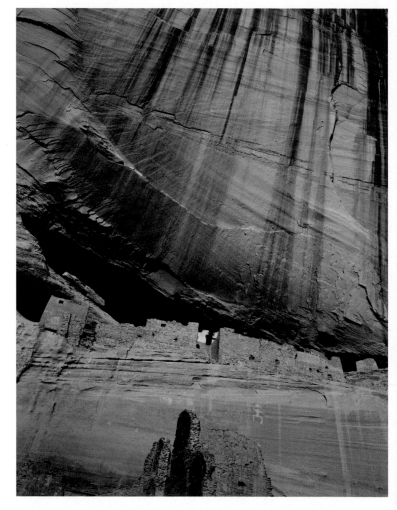

White House Ruin, Canyon De Chelly National Monument, Arizona
While small changes in angle and focal length will often make an
important difference in the final image, large changes will offer
strong variations on the subject matter. White House Ruin in
Canyon De Chelly was first captured on film in the late 1800s by
the great frontier photographer Timothy O'Sullivan, and has been
shot ad nauseam ever since. My first visit to this site resulted in
an image very similar to the iconic O'Sullivan photo, apparently a
rite of passage most photographers must travel.

Dawn, Tahquamenon Falls, Newberry, Michigan
Dramatic subjects often require visual investigation, as standard viewpoints tend to be clichéd. Standing beside Tahquemenon Falls in Michigan's Upper Peninsula, I tried to find some interesting angle, something different from the many photos taken here. Returning before dawn the next day, shooting towards the east from above the falls, I found a combination of light and angle that seemed different from the norm.

Choosing a Viewpoint

Deciding the tripod's location, or where to hold the camera in hand-held shots – selecting one certain viewpoint over the many choices offered in any given scene – is the first choice in the compositional process. This decision also includes the subtle yet important choice of camera level in reference to your composition. Distance from the subject combined with camera height comprises two major decisions that will have a huge effect on the final outcome. The best height for any given exposure will often be eye level, in large part because this is the angle from which most people view the world. When using a tripod, generally this will entail opening the legs to most of their length. That said, this is a rule that is certainly meant to be broken. By altering the expected level, either by dramatically lowering it, or noticeably raising it, interest and tension may be added to a scene. Lowering a tripod down and tilting the head forward – combined with a wide-angle lens – offers the possibility of dramatic near–far arrangements, especially when combined with a deep depth of field.

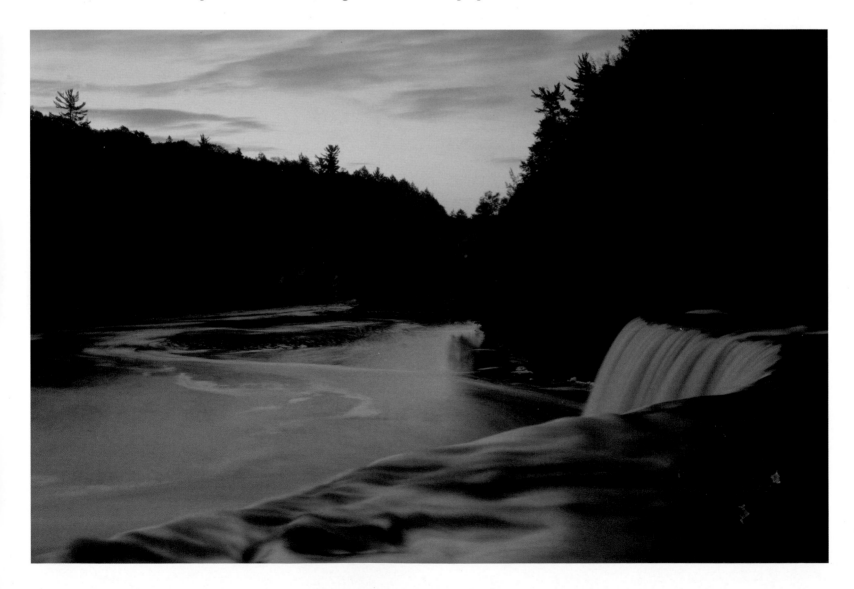

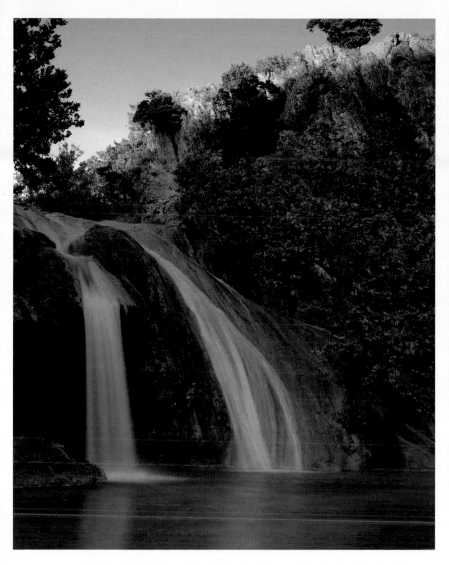

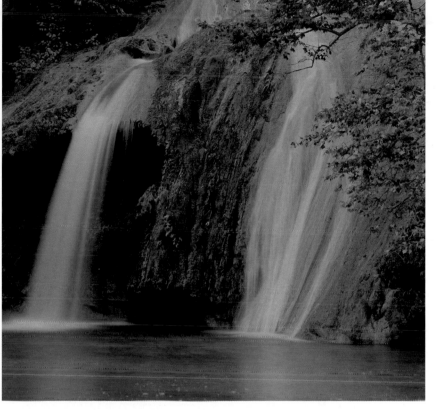

Version one

Version two

COMPARE SHOTS

This is a scenic waterfall in the Arbuckle Mountains of eastern Oklahoma, one of the few in this state. Arriving at Turner Falls late in the afternoon, I set up on the eastern side of the falls, catching the last light on the ridge above the falls (see version one). The angle was decent, and I returned to the campground feeling satisfied. Rising the next morning, I returned to the waterfall, this time setting my camera up on the west side. This angle showed the falls to much better advantage, with the upper bench catching the early sun (see version two). While the first viewpoint was acceptable, the second was a definite improvement.

Turner Falls, Oklahoma

BELOW
South Pond, Scott Matheson
Wetlands Preserve, Utah
Version one

OPPOSITE
Version two

Orientation

Changing orientation implies making an adjustment and, as the term applies to composition, there are several options. Deciding whether an image should be vertical or horizontal is one of the prime choices made during the initial process, and is one of the most important decisions the photographer will make. Other options include employing the square format or possibly using a panoramic format. Any given scene will have one best way to be oriented on film, and this beginning will have a huge effect on the entire process.

When camera level is changed the orientation is also altered. There are other methods that affect this, chief among them the changing of lens focal length. Even slight changes in lens length will alter the image orientation, and the shift from a wide-angle to a telephoto will dramatically modify any composition. Every possible photograph will have an obvious orientation and often this will be the strongest angle for that subject. On occasion, however, it behoves the photographer to explore other angle options. By changing from the obvious, by presenting an unusual view of a subject, interest will often be added to the image.

Tipping the camera will also alter the general orientation and even small changes in angle will greatly modify the outcome. By carefully investigating these possibilities and by keeping an open mind concerning image orientation, a powerful composition may be discovered. Tipping forward causes foreshortening, increasing a feeling of falling away in the image. Tipping the camera upwards will exaggerate the height of a subject, causing a looming effect.

COMPARE SHOTS

Orientation implies a process of adjustment, and in composition, this translates into the best angle on any given subject. This means deciding on vertical or horizontal, and on lens focal length and closeness.

After a rare canyon country snowfall, I went to the local wetlands preserve and found this frosted double branch. It was an obvious foreground element, and the main compositional decision was orientation. My initial response was a close vertical, with the branches as a tight foreground (see version one). This was a satisfying composition on the ground glass but, after exposing some film, I pulled back to shoot a horizontal version. I often do this, as horizontals dramatically outsell verticals in my stock photo business. Taking several steps back and putting a wide-angle lens on the camera – the vertical was shot with a normal focal length – I set up another composition (see version two). The initial, vertical orientation appeals to me, and is a much stronger visual than the horizontal.

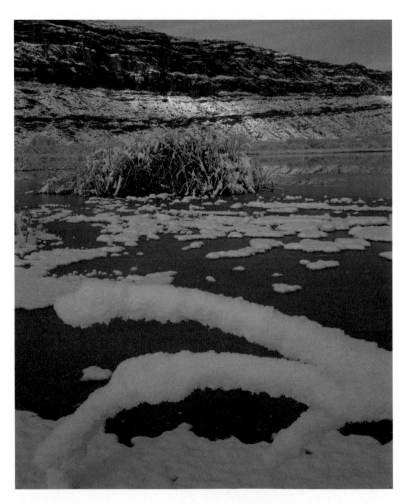

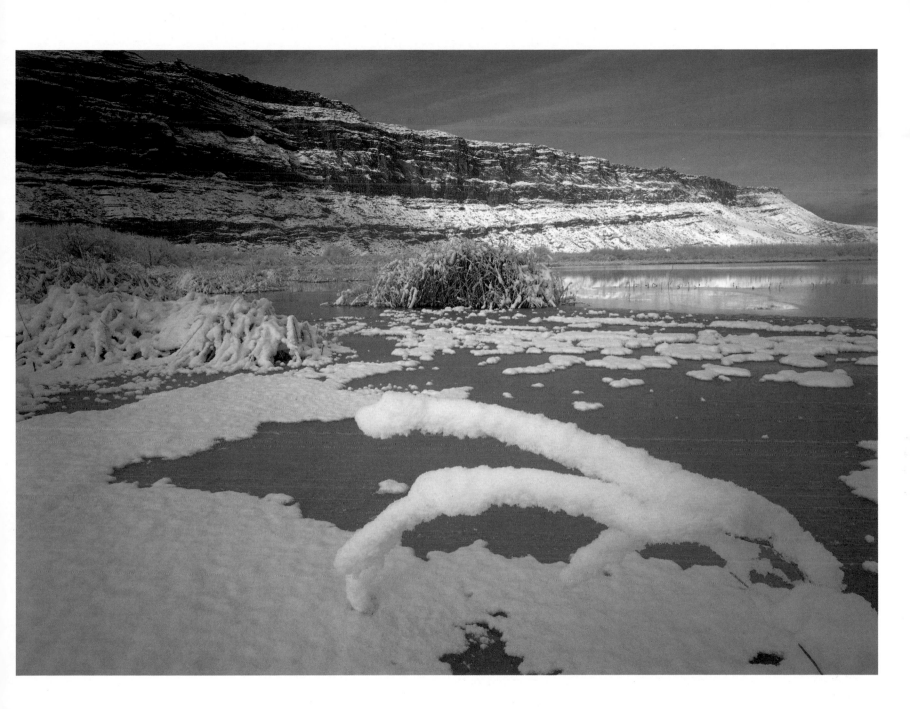

COMPARE SHOTS

A majority of Americans believe the state of Kansas to be monotonous and flat, simply a long stretch of highway on the way to somewhere else. This couldn't be farther from the truth, as the landscape here is subtle, containing amazing and hidden beauties.

During a trip in eastern Kansas, eating lunch in a small town diner, I overheard two old men talking, and one mentioned to the other that a local waterfall was running (which meant the nearby fishing was good, the point of their conversation). Waterfalls always interest me, and I asked for directions.

During the drive, the weather began to change rapidly, presaging impending rain. Walking around a bend in the stream, the falls came into view and I was impressed. By Kansas standards this was a tall waterfall, cascading down a series of small ledges. The pre-storm light was eerie, perfect for this subject. My first composition was a vertical, using the reflection of the falls in the pool at their base (see version one).

After shooting this angle, I flipped the 4 × 5 back and set up a horizontal image. Placing the falls to the left side of the frame, I tried to use the sweep of the cliff to balance out the composition (see version two).

In this case, my initial reaction to the scene was the best and the vertical is a tighter composition. In the horizontal, the space to the right of the waterfall is too empty and doesn't offer any counterbalance to the falls.

RIGHT
Wolf Pen Creek, Kansas
Version one

BELOW
Version two

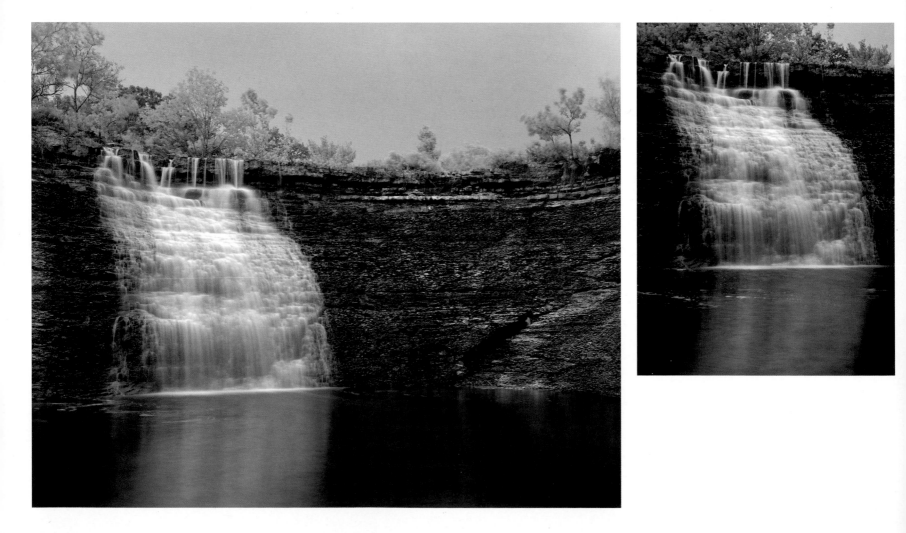

COMPARE SHOTS

The Niobrara is a beautiful river that runs across northern Nebraska, and it is a protected National Wild and Scenic River. While most of the river is calm, with only small riffles, at the lower boundary there is a rapid of some size. My first visit to Norden Drop was on an overcast day with threatening clouds looming over the river. Using a small pourover to lead into the main rapid, and taking advantage of the approaching storm, I set up this horizontal shot (version one). This photo worked fairly well and is a good example of flat lighting.

Several years later, I returned to Norden Drop on a clear day. A large piece of driftwood was lodged over the edge of the rapid, giving an interesting counterpoint to the rushing water behind it, and the low light angle was perfect for this scene (version two).

By approaching this scene from two different perspectives, and by employing very different lighting, the orientation has been drastically altered. The results are two very different images of the same subject, both strong in their own way.

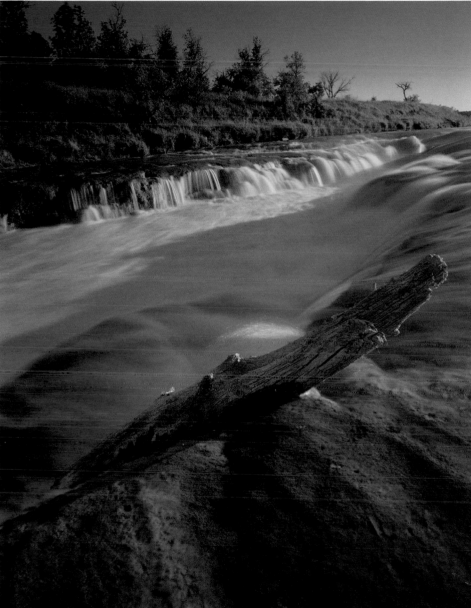

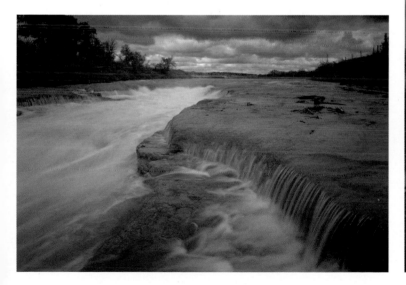

Norden Drop, Niobrara River,
Nebraska
Version one

Driftwood, Norden Drop,
Niobrara River, Nebraska
Version two

Symmetry versus Asymmetry

Maintaining some degree of tension between the design elements in any composition is paramount. Keeping a strong balance between the various shapes and colours within the framework of the image will result in symmetry, leading the viewer's eye on a guided journey through the image. Proportion and harmony are symbiotic in a symmetrical design, playing off each other, balancing the composition. This may be achieved through the use of counterbalancing shapes within the design, or through the manipulation of colours, placing opposing hues in quiet balance.

Asymmetry implies a strong elemental discord in a composition, and this technique will raise a sense of tension within the image. Rather than leading the eye through a scene, this will force the viewer to wander through the photograph, deciding which elements bear more weight. This can occur either through the technique of a disconcerting arrangement of the shapes throughout the image, or by using jagged colours and edges in a tandem design.

An asymmetrical technique – also called a hodge-podge style of composition – can be difficult and requires a fine balance. If the design displays a nice tension between competing elements, this type of arrangement can be successful. When the multiple elements in this technique are too disharmonious, when there is absolutely no cohesion within the image framework, asymmetrical compositions fall apart, becoming an annoying and abstract experience for the viewer.

Dismal River, Nebraska
This photo is an odd mix of symmetry and asymmetry and shows an unusual use of backlighting. The foreground is asymmetrical, with the bright grass and sharp-edged cactus, while the shaded background is muted, with the sinuous river running across the image.

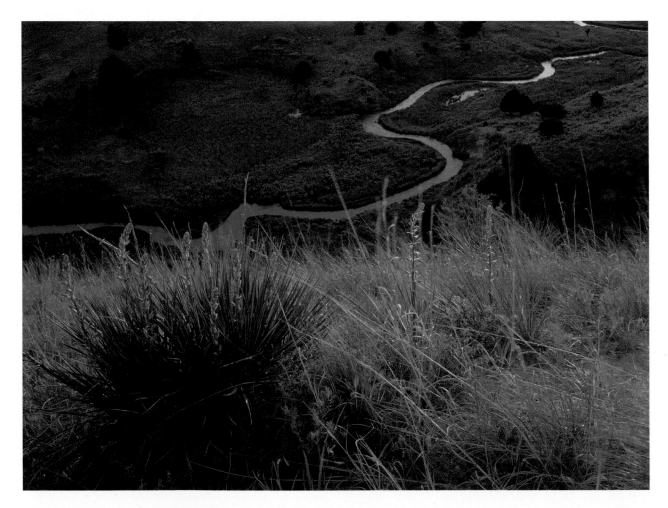

COMPARE SHOTS

Elephant Rock is a limestone arch in northwestern Kansas, sitting on a small hill above the prairie. Not having been to the arch in several years, I decided to stop and shoot some film. A huge thunderstorm was forming as I hiked up the hill, and conditions were looking hopeful. The light during this storm was eerie and the clouds were fantastic. Setting up close to the arch, I included the odd pressure waves in the clouds, placing them above the rock in a tight composition (see version one).

As the storm continued to swirl and gain power I moved slightly downhill, placing a yellow rock in the foreground, with Elephant Rock on the horizon. As I set this shot up, the light shifted into an almost scary warmth, presaging the hell that was about to break loose (see version two).

The first image is a symmetrical composition, with the arch filling the bottom half of the frame, and the repeating cloud patterns echoing the shape of the rock. The second photo is very asymmetrical, as the yellow rock is tightly placed in the bottom right corner and the arch is almost an afterthought in the upper left. This scene is out of proportion, with no balance, and is almost confusing. Despite its oddness, the second photo is my favourite from this trip, perhaps because it breaks so many rules.

After exposing the second shot, my nerve broke and I raced back to my car. Just as I reached the safety of the vehicle, this massive storm broke loose and I sat and watched an impressive lightning storm.

TOP
Elephant Rock, Kansas
Version one

BOTTOM
Version two

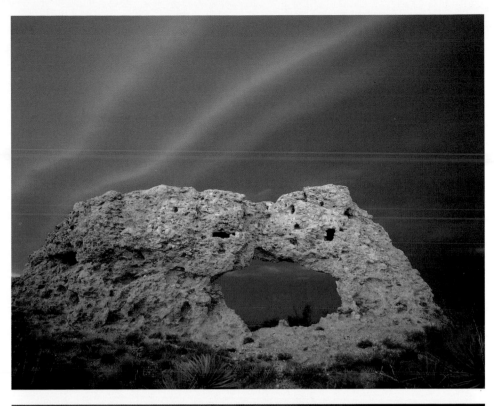

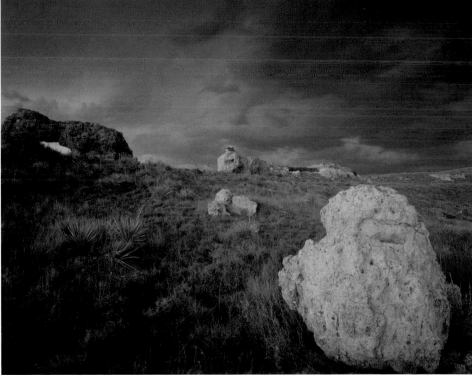

Silo and Barn, Pennsylvania
Barns are hard for me to
photograph, perhaps because
it is difficult to find fresh and
interesting angles on this
time-worn subject matter. They
are also, unfortunately, a very
popular stock image and so I
continue to try, always looking
for something new. Driving
towards a motel after a sunset
shoot, I saw this scene and
pulled onto the verge to take
a photo. The post-sunset light
was nice and, cropping out the
left side of the barn, I took some
shots. This is an asymmetrical
composition, a combination of
the sharp angles of the barn and
silo with the smooth curve of
the far hill.

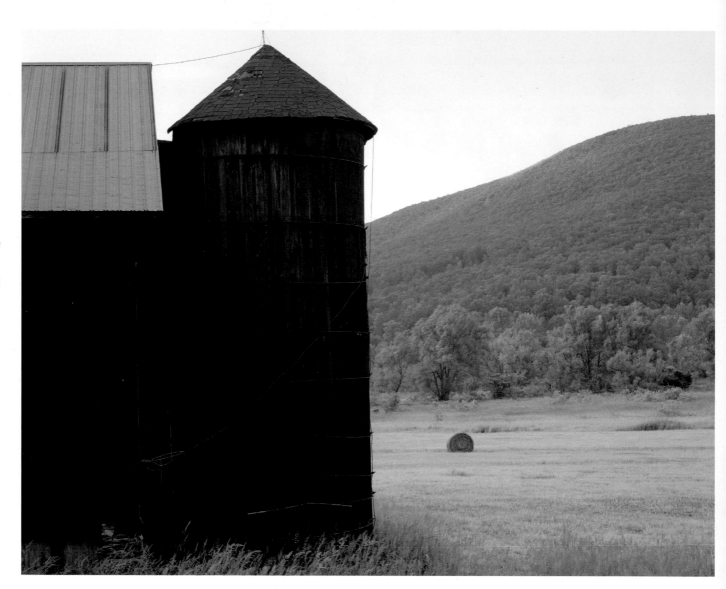

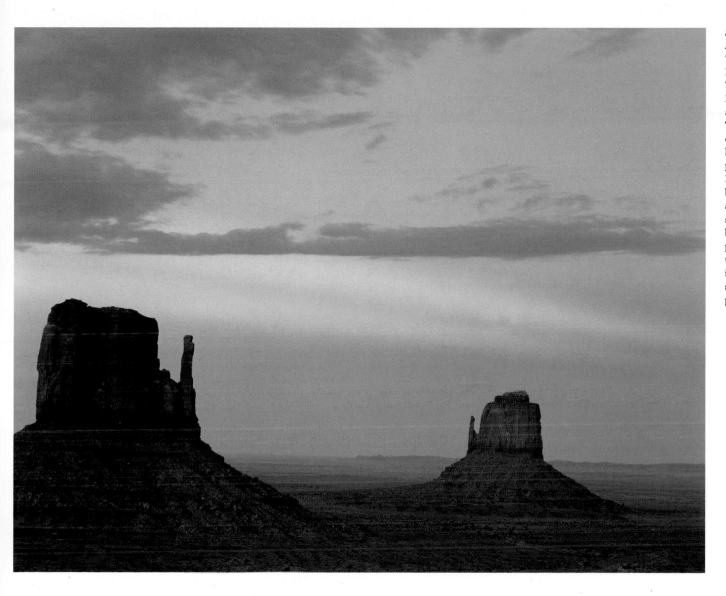

Sunbeams, Mitten Buttes, Monument Valley Navajo Tribal Park, Utah
Made famous by the many Western movies filmed here, Monument Valley has become a major tourist destination. The Mitten Buttes are icons of the valley and are a hugely popular subject for photographers. Over the years I have shot here many times, but with little success. During a recent post-sunset visit, two strange sunbeams briefly flashed behind the Mittens, a subtle pink against the blue sky. This is the best photo I have managed in Monument Valley and is a slightly different take on this popular subject.

Rule of Thirds

Birch and Maple, New Hampshire
In late September the woods of New England explode with colour. This is beautiful, but it can be difficult to isolate an original composition. Walking over Kancanaugus Pass in New Hampshire, this pattern of autumn colours caught my eye. The white birch trees are strong design elements, and this is a variation on the rule of thirds composition. The intense hues of the leaves, both red and yellow, offer a visual counterbalance to the strong graphic of the trees.

The rule of thirds is a standard in any compositional discussion. By dividing a scene into thirds – either horizontally or vertically – and arranging the dominant shapes into these sections within the image, a strong balance is achieved. This works extremely well in a near–far vertical arrangement, allowing a strong compositional flow within the scene. Placing a strong graphic in the immediate foreground, allowing a blank space in the middle, and then placing a dominant shape in the upper third leads the eye through a strong and uninterrupted journey through the photo. The use of a benign space within the middle third strengthens the other sections, keeping a strong flow within the photo.

This balancing act will also work for horizontal scenes. By placing a strong shape within the left third, the viewer will begin here, and follow through the image. Using a blank area in the middle will push their eye to the far right, where another strong shape should finish the composition.

As with all compositional rules, the thirds technique may be broken with impunity. Employing strong graphics within all three sections can work well, as can using two of the areas as blanks, placing a powerful element in the remaining third. This will often be a combination of thirds and asymmetry, and when done well, can create a powerful image.

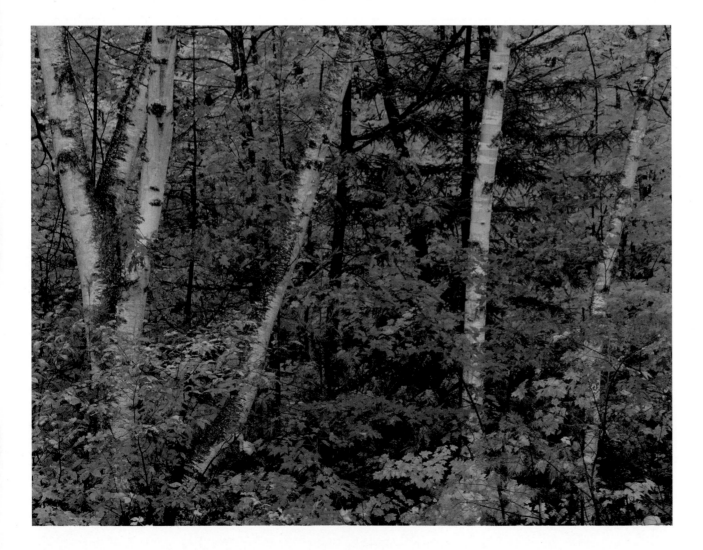

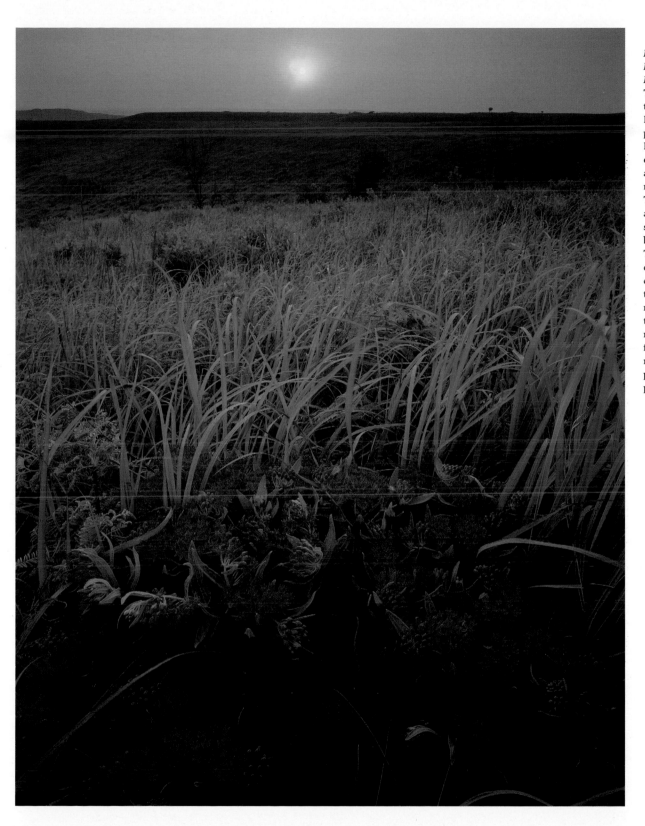

Butterfly Milkweed, Konza Prairie Research Natural Area,
Riley County, Kansas
This image is from the fantastic tallgrass prairie in central Kansas, the largest extant prairie left in the U.S. Every spring the prairies explode with various blooms and the butterfly milkweed is my favourite of these flowers. This photo was taken just after sunrise with a neutral split-density filter applied to bring the sky density down. This is a classical vertical thirds composition, with the various colours dividing the scene into three distinct sections. The red milkweed fills the bottom area, the green grasses occupy the middle and the far hills and sky finish the upper section. This remains one of my favourite photos from the tallgrass prairie.

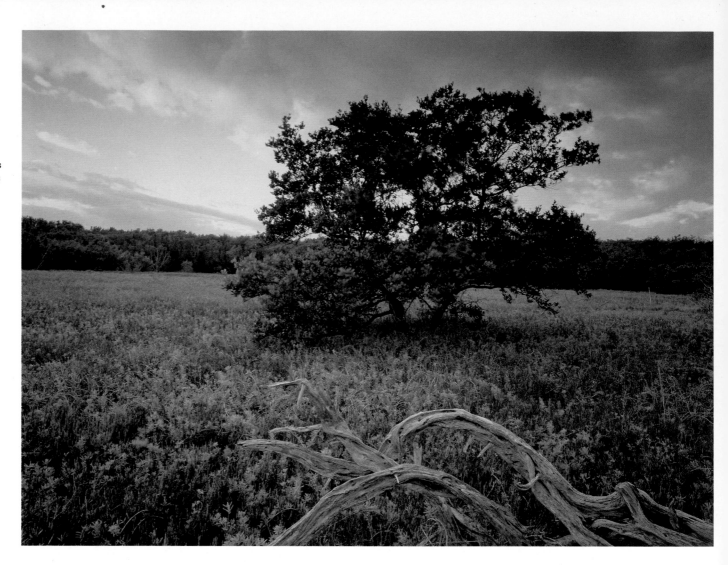

Snag, Everglades National Park, Florida
The rounded shape of the foreground snag gives a base to this composition, and the tree combines with the coloured hues of the clouds to complete it. This is an odd arrangement, with the rounded snag curving back into the foreground, but is a case of bending the rules to make an image work.

Weighting Photographs

A variation on the thirds technique involves weighting the image by placing a powerful subject element within a relatively small portion of the photo. One good way to employ this technique is bottom-weighting, using the lower section of the composition to control the scene by dropping the strongest graphic into this area. This gives the image a base, and draws the eye into the photograph, allowing the upper part of the scene to exist quietly with the graphically stronger bottom. This technique will also work with a side-weighting, usually by placing the main subject far into the left edge of the image. This also draws the eye, first to the left, and then into the more benign right area. Top-weighting is a harder technique to pull off, as it introduces a strong feeling of top-heaviness to the photo, but there will be rare occasions when this approach will work.

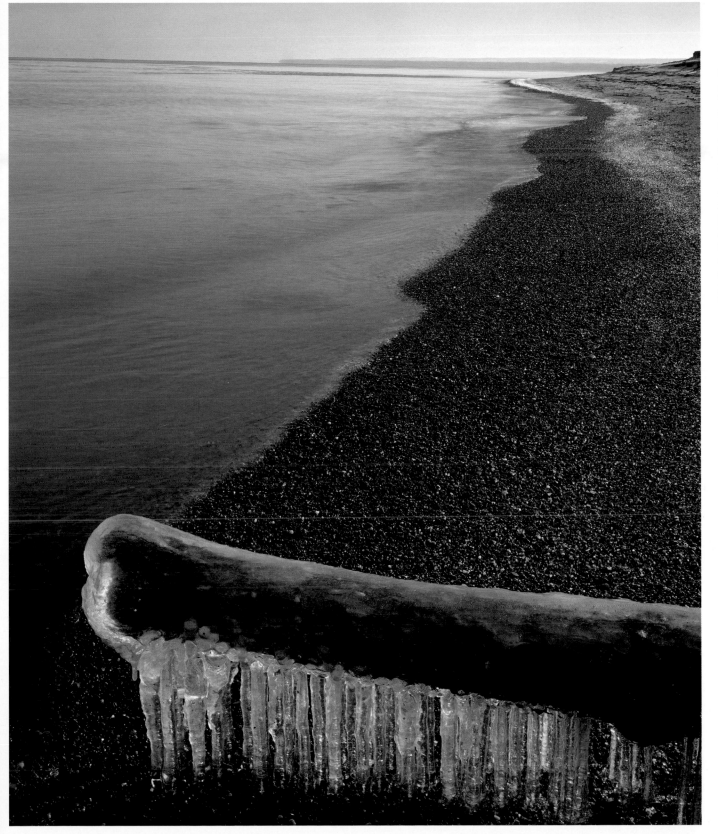

Iced Driftwood, Budny Beach, Pennsylvania
This odd ice formation is an example of a foreground shape being the total focus of a composition. I included the beach and horizon line to give scale to the image and to accent the branch. The ice hanging down from the driftwood is backlit, a rare instance of this lighting style working in a landscape image. Despite the multiple rule infractions on display here, the composition seems to hold together, perhaps because of the strong bottom weighting.

Dawn, Delicate Arch, Arches National Park, Utah
This was taken on my first visit to Arches National Park, after spending the night at one of the viewpoints adjacent to this wonderful arch. Just before sunrise, there was a towering cumulus cloud swirling over Delicate Arch. Using the widest lens I had, this composition jumped out on the ground glass.

This is an example of severe bottom weighting, with the black horizon line supporting the huge sky. The arch has become a lesser element in this composition, although it is still very important, adding a small surprise to the greater scene.

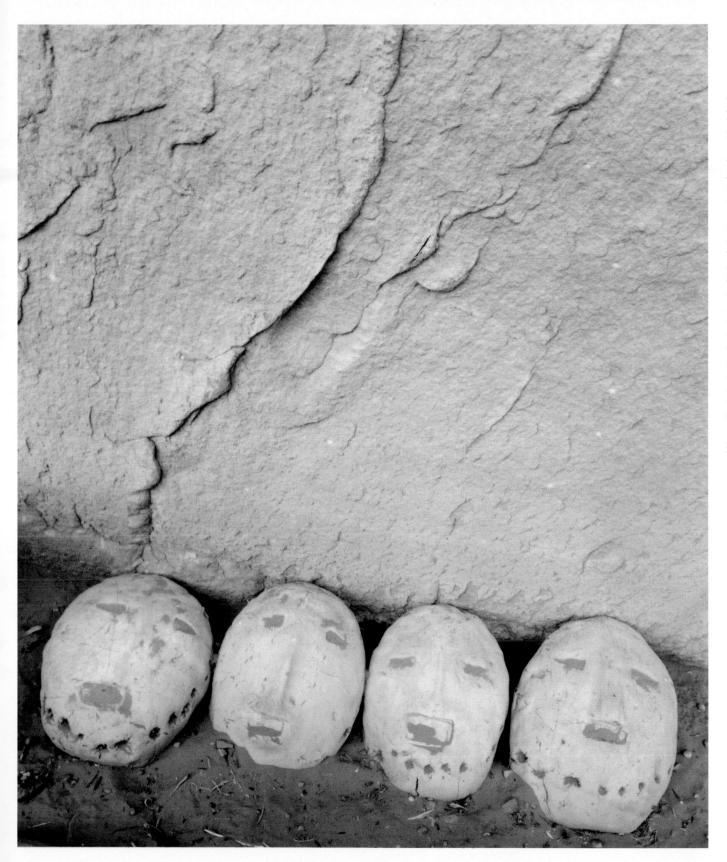

Four Yeibeichai, Cannibal Cave, New Mexico

These four prehistoric pottery heads have been lying in this shallow cave for one thousand years, a remnant of the ancient Anasazi culture that flourished in the Four Corners region of the U.S. Photographer Tom Till showed me some pictures of the heads and I was completely intrigued. Another friend, Gary Voss, happened to have the proper Navajo tribal permit to visit this area and was happy to take me. This is a strong example of bottom weighting, as I put the heads low in the image, filling the rest of the photo with the light rock wall. The dark line in the wall is fortuitous, as it drops onto the left head, adding some interest to the otherwise featureless wall. While my initial composition was looser, I felt that it improved as I gradually moved in closer to the heads.

Leading the Eye

In most compositional styles there must be a strong effort to lead the eye into a scene. There are innumerable methods to achieve this, such as graphic lines leading into the main composition, a strong foreground element flowing into the photo, or other, more subtle techniques. An asymmetrical arrangement can lead the viewer into the image through a careful – albeit appearing haphazard – arrangement of shapes. Using foreground elements that travel into the entire scene is often a successful technique, particularly in architectural photographs. In landscapes, a plant that begins in the foreground and runs all the way through the composition will lead the eye on a satisfying journey.

Foreground elements are important, not least because they may be used to draw the viewer's eye into a scene. The classic foreground will occupy the bottom area in a composition, leading the eye into the upper section. There are exceptions, and elements can be on the side of an image, drawing the viewer in from this angle. These side shapes will usually begin on the left side, leading over to the right; this is a classic Western orientation. The opposite side, however, may work in certain scenes.

Redbud, Elk Falls, Kansas
Elk Falls is the premier waterfall in Kansas and is a site I often visit, always searching for new perspectives. Early spring had brought this redbud to bloom and it was a perfect addition to the waterfall, giving a fine possibility to the scene. Running the tree up the left side of the photo, using the blue rocks as a foreground base, I placed the waterfall in the upper right corner. The rocks lead the eye to the tree, which then draws the viewer up and over to the waterfall. This was one of the best colour images I have found in Kansas, and so, of course, it has never sold.

Flash Flood, Canyonlands National Park, Utah
There are myriad techniques that will draw a viewer's eye into a
scene, and one method in black and white is to use a highlight to
pull attention into the image. As the eye is drawn to highlights,
I used this as an enticement to draw the viewer up into the middle
area, with the upper highlight completing the composition.

Shapes and Object Relationships

During photo sessions, an overriding concern must be the discernment of shapes and their relationships with each other in any given scene. These may be simply geometrical, or they might be colours balancing within the various shapes. How the shapes within a composition relate – both with each other and in the greater scheme of an image – will combine to create a strong composition (or will conspire to ruin a photograph). By focusing your eye past the viewfinder, and softening the scene presented in the camera, the dominant shapes will become obvious.

Fall-Watching Residence, Huang Shan, China
This distant waterfall was made famous in the wonderful film *Crouching Tiger, Hidden Dragon,* and the house was one of Chairman Mao's retreats. This building is set in one of the most picturesque locales imaginable, but an interesting composition eluded me. Changing angles on the house wasn't helping and I finally moved back. Noticing these odd light covers, and placing them in the extreme bottom right corner, the scene came together. The various shapes within the frame – the light covers, the flags, the curving roof and the overhanging tree branches – all conspire to draw the eye in a full circle.

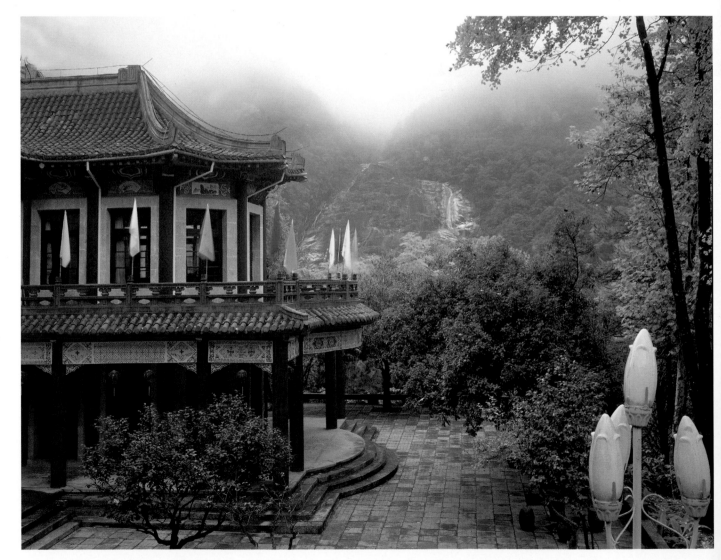

Symbiotic Balances

Everything in the visual world – both natural and man-made – exists in a symbiotic relationship. Using a viewfinder to carve select slices out of the world and then placing them on film is a prime purpose of photography. Capturing a fleeting instant, either of harmony or discord, can be a sublime achievement. Arranging shapes and objects within the viewfinder, tweaking a composition until it falls into place, involves taking advantage of symbiotic balance.

Smooth shapes are those that have curving, rounded edges, and these exist everywhere, both in the natural and within the man-made world. These are invaluable within the framework of photographic composition, offering multiple styles, often using a curve to draw the eye into a scene. Rounded rocks, sand-dune edges, stone fences, stairway balustrades – the list is endless, and the possibilities boundless. When these are combined with angled shapes, powerful compositions may be created.

Hard shapes are those that have sharp angles, and these also exist in abundance. Man-made objects are often hard-edged, but these shapes also exist in the natural world. Metamorphic rocks often display this quality, as do steep cliffs and primeval woodlands. These shapes add a strong tension to a photo, and, when they are mixed with smooth objects, a wonderful and often discordant balance may be achieved.

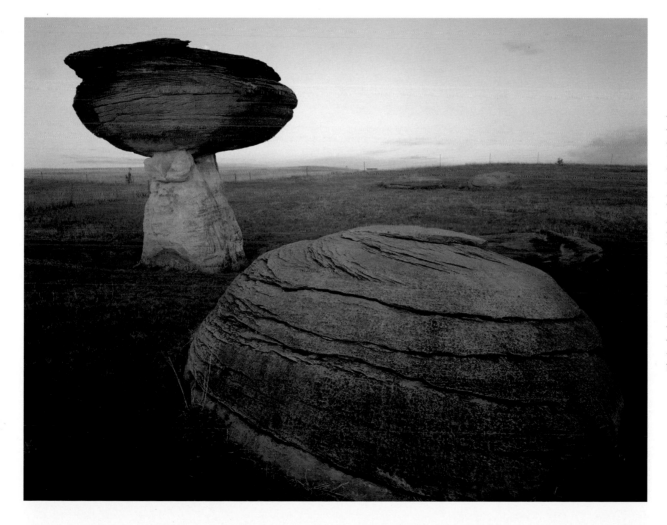

Mushroom Rock, Concretion, Mushroom Rock State Park, Ellsworth County, Kansas
Mushroom Rock is a geological anomaly in Kansas, a remnant from the retreat of the glaciers at the end of the last Ice Age. These concretions are amazing and one of the premier subjects in the Sunflower State. Waiting for post-sunset light, I placed the foreground rock in the bottom right quadrant of the frame, balancing it with the rising rock in the upper left. The rocks mirror each other, and with one being in the ground while the other is on a pedestal, there is a strong balance between their shapes.

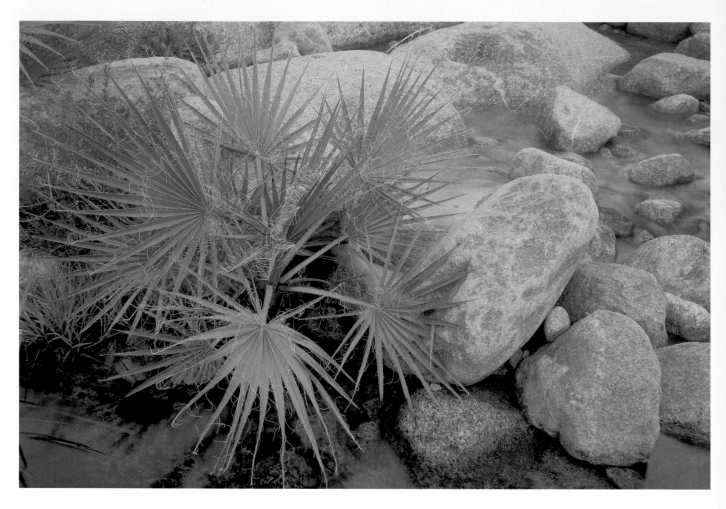

Fan Palm, Guadalupe Canyon, Mexico
Guadalupe is a fantastic canyon in northern Mexico, and the entire area is composed of blue granite. This scene is a mix of symmetry and asymmetry, as the rounded blue rocks and soft orange reflection are contrasted with the jagged, asymmetrical fan palm. This was the best image I took during my visit to Guadalupe Canyon and remains a colour favourite.

Simplicity and Complexity

Smooth shapes tend to be simple, while hard ones run towards the complex. A series of jagged lines running at multiple angles within the framework of a scene creates complexity within a photo, while an undulating row of gentle shapes generally will make a pleasing and simple composition.

In reality, there will almost always be a mix of hard and soft objects in any given scene, with one type having dominance. Through a delicate blending, and with careful framing, the two can play off each other, adding lustre to any composition.

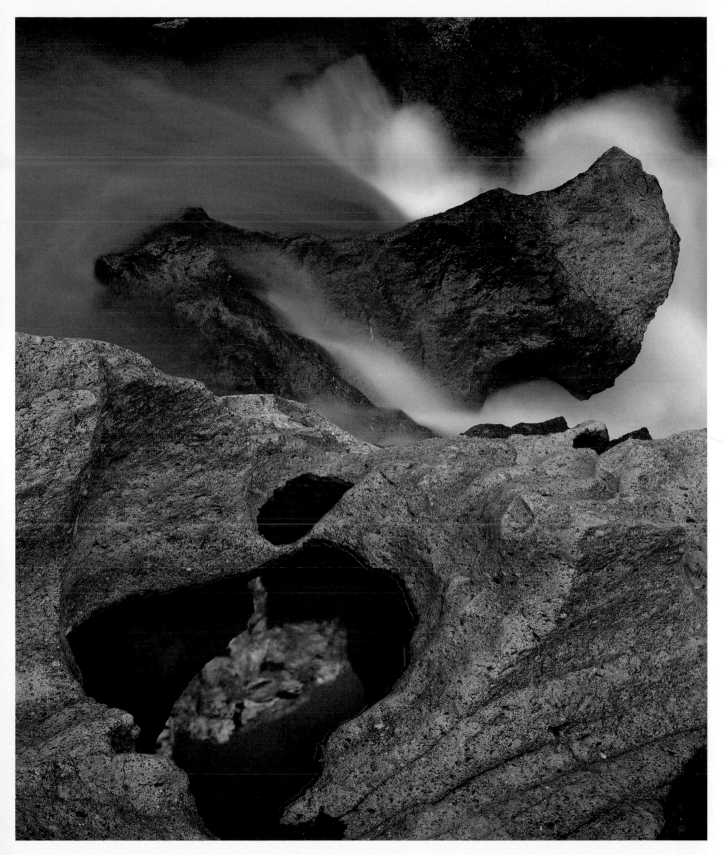

Pothole, Basaseachic River, Mexico
The Basaseachic is a small river in central Mexico and over aeons has carved a fluted channel through the limestone. Walking along the banks, I found this small pothole reflecting the far canyon wall. A strange knob stuck up from the centre of the river channel and these many elements seemed to hold promise. Fussing with angles and lenses became frustrating as no cohesive image was happening. Finally, stepping back and reassessing the scene, the combination of pool and river came together for me. This is a composition of some complexity, but the myriad aspects work together.

COMPARE SHOTS

Hiking up a side canyon in Arches National Park, I found a claret cup cactus in spring bloom. The red flowers were isolated in the midst of a thick bunch of cacti, and this simple composition leapt out on the ground glass. The five flowers were placed on the right side of the image, giving a balance against the thorny claret cups (see version one, opposite). Several years later, in a different part of the park, another claret cup caught my eye. Growing alongside a small, dead tree, this cactus had a profusion of flowers, which, combined with the branches on the snag, created a difficult scene to compose. After some time fussing with camera levels and angles, I finally settled for this shot (see version two, below). This is a more complex arrangement, which lacks the clean cohesion of the first photo.

OPPOSITE
Claret Cup Cactus, Arches National Park, Utah
Version one

RIGHT
Claret Cup Cactus, Arches National Park, Utah
Version two

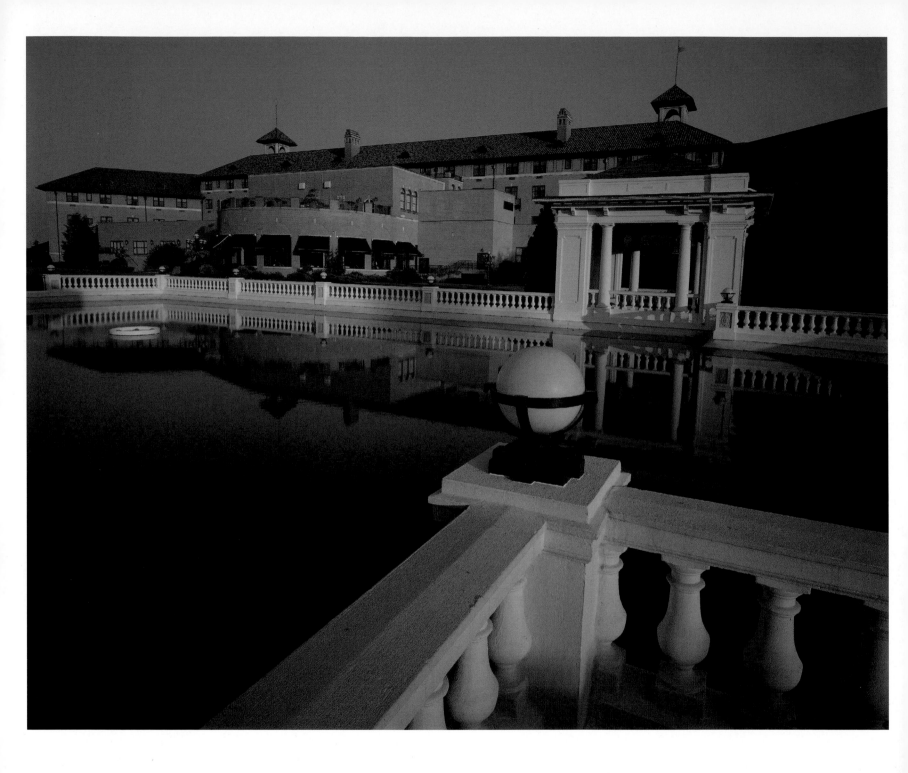

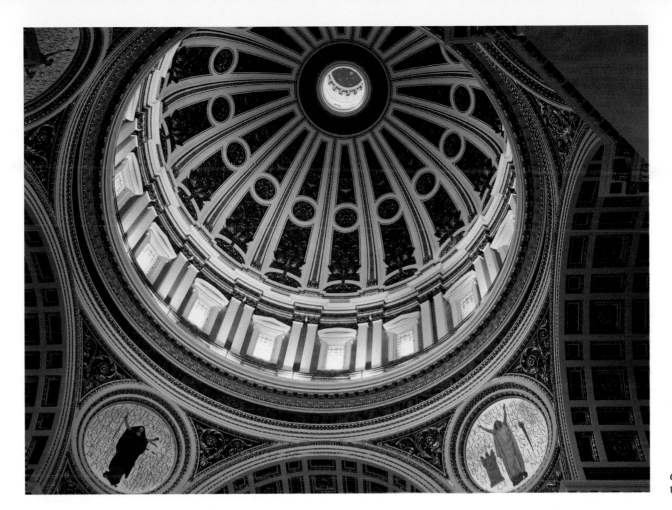

Capitol Dome, Pennsylvania
Using simplicity.

Simple and Complex

Architectural photography is an art unto itself and the experts are able to forge compositional cohesion from what is often chaos. While this is not my area of expertise, occasionally I am called upon to attempt it.

The Hotel Hershey is a grand, sprawling building, surrounded by lovely, well-manicured grounds. Using this pond next to the hotel as a foreground, I included a small white light globe mounted on a white balustrade. The main building occupies the background and this is a complex composition, with many elements coming together to form the whole (see picture left).

The Pennsylvania State Capitol Building has an impressive interior dome, and it is surrounded by a series of circle motifs. Using a moderate telephoto lens and tipping the tripod head and camera almost to vertical, I isolated a composition that emphasized the circles, matching the main dome against two smaller panels. This is a fairly simple arrangement, basically a balance of several circular forms (see picture above).

OPPOSITE
The Hotel Hershey, Pennsylvania
A complicated shot.

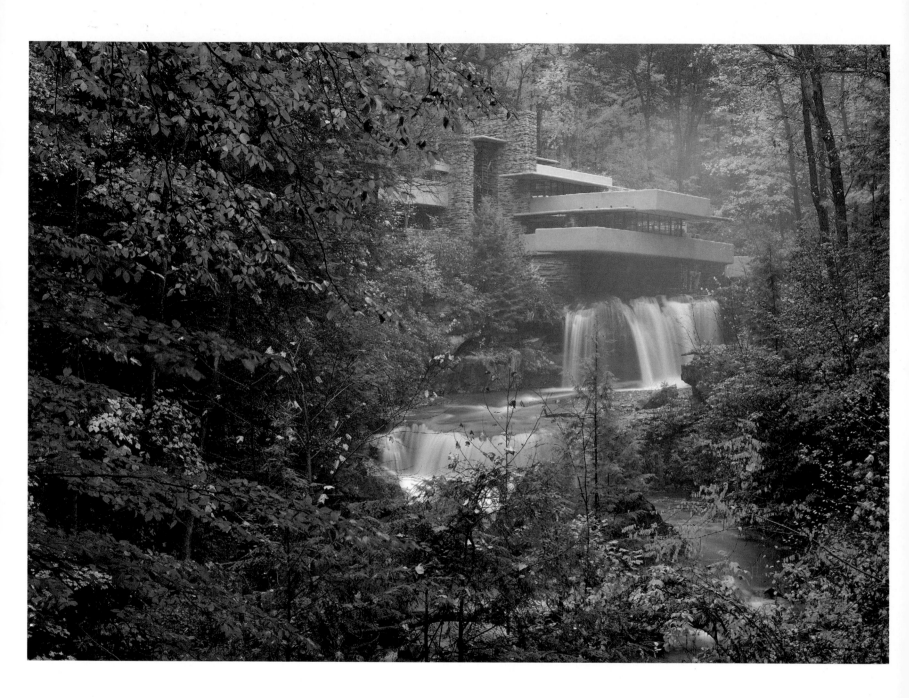

Framing the Subject

The actual framework involved in a photo is very important. The elements that are cropped out are of almost equal importance to the ones left within the image. Carefully choosing which shapes, colours and tones will reside in a photograph and then arranging these into a symbiotic balance should result in a strong and successful photograph.

The placement of the central subject within the scene will determine where all the other elements will reside and will also introduce the concept of frames within the main frame. This is a strong compositional technique and it adds a subtle and important aspect. A good photograph will have several things happening within its framework, a dominant centre of attention surrounded by lesser shapes, objects or colours. These secondary happenings will bolster the main subject, and are often the signature of an excellent image. This may be achieved through a technique as simple as throwing a background object into soft focus, or by mixing an opposing style of shape around the strongest element. Employing this frame within a frame style will add interest to any scene, drawing the viewer into the photograph.

LEFT
Fallingwater, Pennsylvania
Fallingwater is architect Frank Lloyd Wright's masterpiece, and it is very photogenic. Hanging over a small waterfall, the multiple levels and cantilevered balconies are stunning. This is an example of a frame within the framework of the image, where the surrounding leaves were circled around the house, drawing attention to the main subject.

RIGHT
Oneseed Juniper, Garden of the Gods, Colorado
The snow accents the shape of the trees, delineating them from the background cliff. The opposing curves of the two trunks are a strong example of the technique of using elements within the image as a frame. The S-curve trees flow through the composition, gradually drawing the eye into the image.

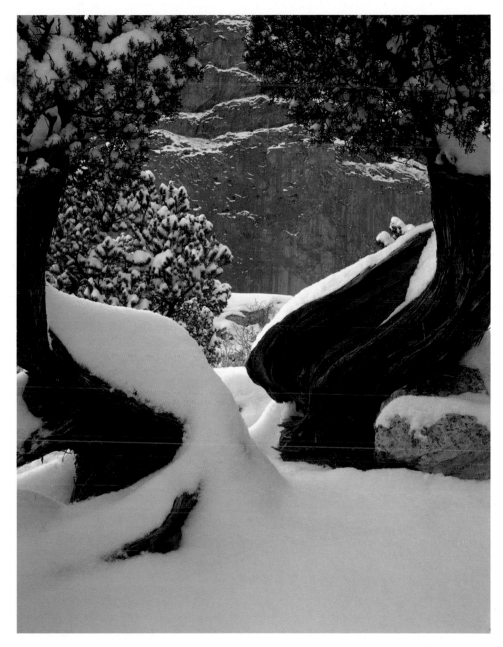

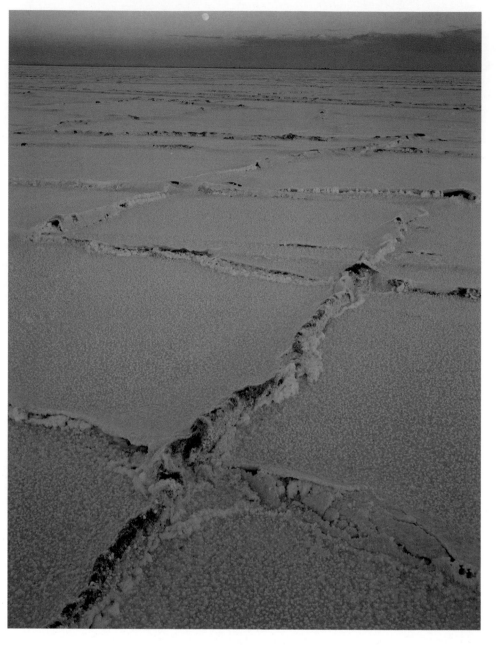

Compositional Range: Abstraction to Realism

There is an enormous range of possibilities pertaining to compositional styles and there is often an overlap, as this spectrum has loose edges. Abstraction is a strong approach but can be too personal, having meaning only for the photographer. When this style is used to the extreme the viewer is often confused, which leads to an unwillingness to put any time and effort into understanding the image.

When abstraction is leavened with hints of reality a photograph becomes approachable, giving hints towards the subject matter. This will add great allure to a scene, drawing the eye in with its inherent possibilities. As an image travels across this spectrum it slowly leaves abstractionism and begins to enter realism. The middle part of this transition is very interesting, especially when seasoned with equal parts of the opposing ends.

Realism takes many forms, ranging from the grand and pristine landscape or the hard edges of city buildings to the tough world of photojournalism. These photos will often employ classic compositional styles, with the rule of thirds being a favourite approach. Hard shapes are often included, with the softer shapes generally used to a lesser degree.

During a visit to Utah's Bonneville Salt Flats, after the sun had dropped below the western horizon, I noticed these interesting patterns in the dried salt bed (pictured left). The distant horizon was picking up the warmth of the sun, but the salt had turned a pleasing, cool blue. Patiently wating until after sunset will often reward the photographer.

COMPARE SHOTS

Moving in on a composition is always a productive technique and cropping out extraneous elements will strengthen an image. During a seven-day mule trip deep into a remote mountain range in Baja, Mexico, we rode into a strange slot canyon filled with tall palm trees. The small stream reflected the sheer canyon walls and fallen palm fronds lined the banks. Dismounting and unloading my camera, I set up and shot some film (see version one).

After studying the ground glass and deciding there were too many distracting elements in the scene, I moved closer, focusing in on the near palm frond (see version two). This second composition is better as the design of the fronds is accentuated and several distracting elements have been cropped.

OPPOSITE
Bonneville Salt Flats, Tooele County, Utah
The Bonneville Salt Flats in northern Utah are famous for the many land speed records set there, but the area is also amazingly photogenic, particularly after a heavy rain. The subsequent drying causes small upheavals within the salt crust, creating geometric designs, an unusual occurrence in the natural world.

BELOW LEFT
Palm Fronds, Sierra San Francisco, Mexico
Version one

BELOW RIGHT
Version two

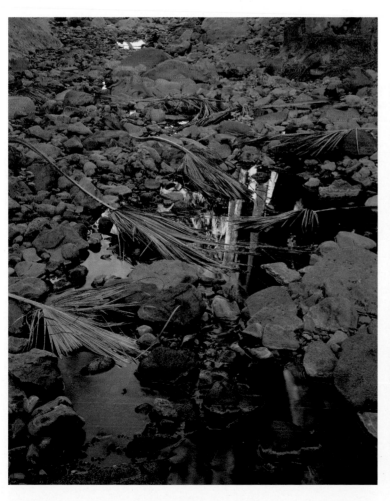

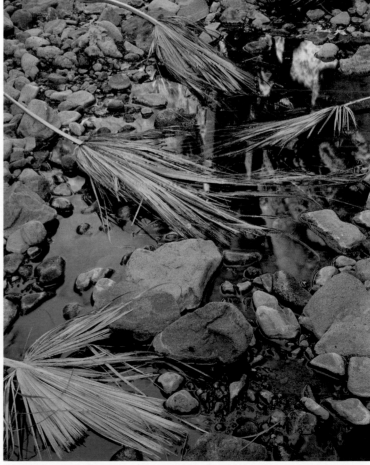

Sumac, Konza Prairie, Kansas
The Konza Prairie Preserve in eastern Kansas is one of my favourite subjects for colour, always rewarding my visits with at least one decent image. Arriving on a late autumn day, the haze was horrible and the possibilities seemed slim. Driving into town for lunch, I decided to take the afternoon off and watch a movie. When I left the cinema a strong wind had cleared the ugly haze and a lovely sunset was beginning. Quickly driving to the eastern boundary of Konza, I glimpsed some bright red sumac, pulled over and hopped the fence. By this time, the sun had gone below the far horizon and some distant haze was creeping back. The light was weak as I set up the view camera, starting a long exposure. I carry a small strobe in my pack, and began to walk among the sumac, firing the flash on select bunches of leaves. After ten minutes the light was hopelessly waning and I gave up, closing the lens, and trudged back to my truck.

The single ten-minute exposure was a happy surprise when the film came back, with the lit-up Sumac having a rich red colour and the distant horizon nicely hazed over. On this occasion, my intuition failed me, and I should have been in the field rather than in a movie house.

The Art of Intuition

Intuition is, in essence, the ability to sense something without having any knowledge of the situation. This is very important in photography, especially as it applies to composition. When a scene coalesces together in the viewfinder, when a composition leaps out at the photographer, this is a form of intuition. This often involves breaking all the rules involved in composition, but when a scene feels right, nothing else matters.

One of the strongest rules of composition prohibits placing a line directly through the photo, either horizontally or vertically. There are occasions, however, when this will introduce a strong tension, dividing the photograph into separate stories. Everyone has intuitive abilities and this trait can be developed and enhanced through use and practice.

Occasionally intuition will fail the photographer, and what seemed a visual feast at the time of exposure will fail to translate into a decent image. And sometimes the opposite will happen, where a scene hardly seeming worth the bother of making an exposure translates into an image of exquisite quality. Intuition is a trickster, but it will reward the receptive eye and these doors to perception should always be left open.

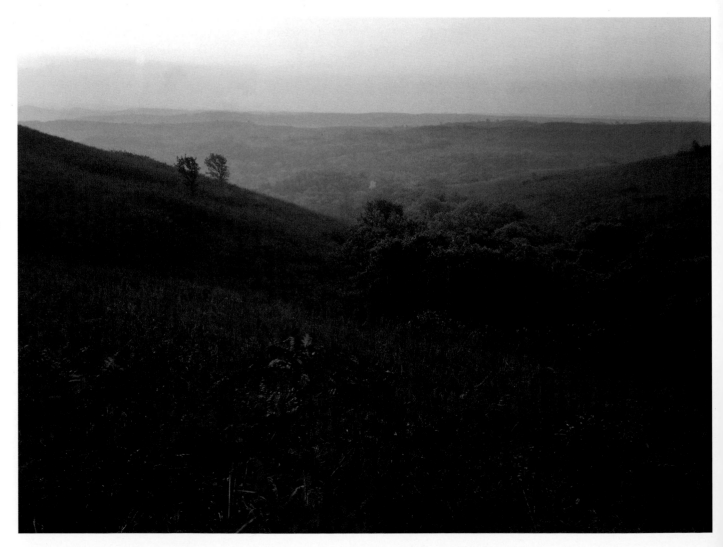

COMPARE SHOTS

Moving away from an obvious orientation will sometimes add interest to a scene and this possibility should be explored with every composition. Hiking down one of my favourite canyons on a cold winter day, I was pleased to find this tall ice column flowing out from a small arch. Setting up my view camera, I composed the obvious shot, a vertical of the huge icicle (see version one).

After this, I began to explore other options, moving to the left and changing lenses. Putting the column in the right side of the frame and using the red wall and frozen pool as a counterbalance, I flipped the camera back and exposed a horizontal (see version two).

Both photos are decent, and the initial vertical exposure is strong, but the horizontal image is better, perhaps because it is a less obvious angle on this scene. By altering my approach and moving past my initial reaction, I found a second, more interesting, composition.

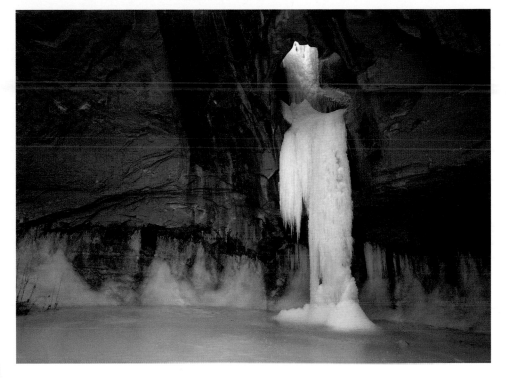

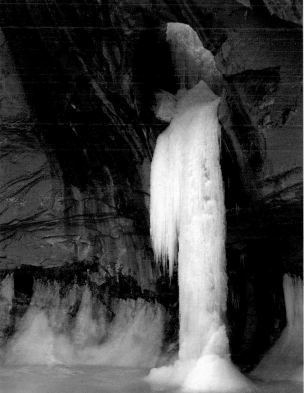

ABOVE
Arch, Windwhistle Draw, Utah
Version two

LEFT
Arch, Windwhistle Draw, Utah
Version one

Three:
Exposure & Focus

Bracketing. Motion. Depth of Field. Up to Speed.

Bison Skull, Konza Prairie
This big bull buffalo had become ill-tempered and violent, attacking university researchers working in the preserve. This behaviour earned him a death sentence and the preserve manager gave me the skull as a gift. Of course, I immediately used it as a prop for a photo, placing it in the tallgrass for a dawn shoot. As is often the case, the prairie winds were unrelenting, almost making me cancel the session. Deciding to work with the conditions, I set up a shot, using a long exposure to exaggerate the wind-blown grasses. The dawn sun lit up the background and the skull and foreground grass remained still during the exposure. This is a decent use of motion and stillness and the composition is a personal favourite.

EXPOSURE AND FOCUS ARE VERY IMPORTANT technical components of composition and both may be used in a creative manner to enhance an image. Exposure is a mundane aspect of photography but when it is botched the final print will invariably be ruined. Proper exposure of any kind, whether for black and white, colour film or digital capture, is relatively simple, requiring only a basic understanding of how light meters translate a scene to film or file.

There are many extremes of contrast that a photographer will have to deal with, all requiring a basic understanding of exposure technique. These will range from soft, low-key scenes that will offer a pastel palette of colour and tone across the scale, to the harsh and unforgiving contrast of a high-key image. Translating these various degrees of contrast successfully into a photograph will demand that the photographer has a strong comprehension of metering.

All meters are calibrated to a middle tone, known as a seven per cent reflectance grey. In essence, the meter will absorb all degrees of light intensity found in a scene, averaging it all out to a middle grey, calibrating the exposure based on this average reflectance. If a scene has more highlights than shadows, the meter will compensate for this circumstance, tending to give too short an exposure. Conversely, if dark tones predominate, the meter will tend to give an exposure that will be too long, overexposing the scene.

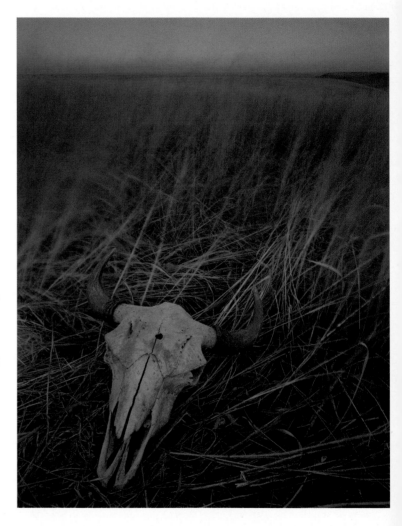

By metering different areas within a scene and then combining the different readings into a balanced exposure, the final image will, in most cases, be properly exposed. This is a simplified explanation of how best to make a meter work, but with practice and experience this technique will give reliable results. When any given scene has a balance of light and dark tones the averaged reading will probably be good, but several closer readings should still be mixed and then the resulting exposure compared with the initial one.

If a highlight reading is f/22 at 1/60th, and a shadow reading is f/5.6 at 1/60th, a workable exposure will be f/11 at 1/60th. This is a balance between the two readings, in essence giving an averaged exposure. When shooting colour film (transparency or negative), a reliable metering method is to take a close reading of only the main highlight and open the aperture two stops from the indicated exposure. This will control the highlight densities, giving them strong detail. This is a reverse of the Zone System, since you are exposing for the highlights (in the traditional approach, the shadows always determine the exposure).

For black and white, take a close-up reading of a strongly detailed shadow and close the indicated reading down two f-stops. This will place the shadows in a zone with strong detail, an important aspect of black and white photography. Again, this is an extreme simplification of the Zone System, but is the essence of this method. Highlight details are then controlled by development, with a decrease from the recommended normal time bringing the contrast down and a push in time increasing highlight densities.

f-stop
The unit in which lens apertures are measured. Each whole step in the f-stop sequence represents a doubling or halving of the amount of light admitted.

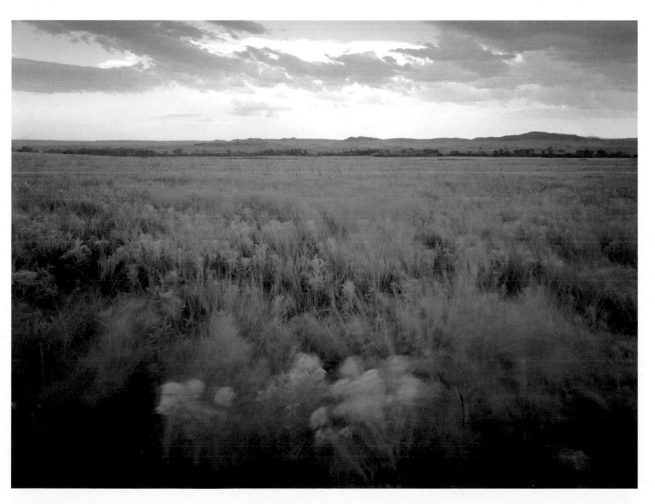

Prairie Winds, Nebraska
The prairie wind can be merciless and it has often forced me to cancel photo shoots. On this occasion I decided to work with the wind, using a long exposure to blur the image. But this photo doesn't work, as the colours are too muted and the contrast is inadequate.

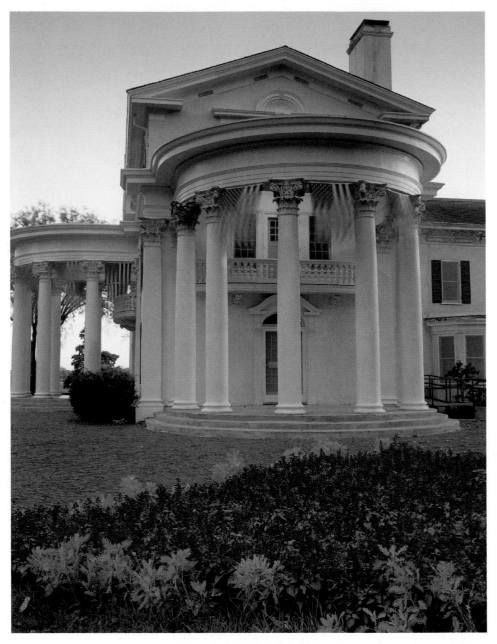

Bracketing

In every case, whether the format is analogue or digital, exposures should be bracketed. That is, after selecting a shutter speed and aperture combination as optimal for a scene, take additional shots on both sides of this main exposure. This may be done by moving one f-stop each direction: if the main aperture was f/11, shoot once at f/8 and another frame at f/16.

The alternative is to bracket the shutter speed: if the main speed was 1/60th, shoot once at 1/30th and again at 1/125th. These added exposures are insurance, just in case the selected exposure is wrong. The odds are good that one of the two brackets will be correct, as a three-stop range is wide, and should contain a good exposure.

There will be times when bracketing isn't possible, when an average meter reading has to be trusted. Photojournalism, action photography and aerials are some examples of this and in these cases, where fast reflexes override all other considerations, experience will assist the photographer. Knowing how your film reacts to different lighting situations comes with practice and consistent results will be possible.

Motion, Morton Mansion, Nebraska
This mansion is in a Nebraska State Park and the photo was taken on a windy afternoon. The movement of the flags during a long exposure adds some interest to what is otherwise a fairly mundane architectural photo, certainly one of my weaker attempts. As the scene was unexciting to me, I didn't follow my normal routine of bracketing on both sides of the main exposure, which was a mistake. This photo needs to be slightly darker, with heavier neutral-density filtration to bring down the upper part. If these corrections had been done, perhaps the image would be stronger.

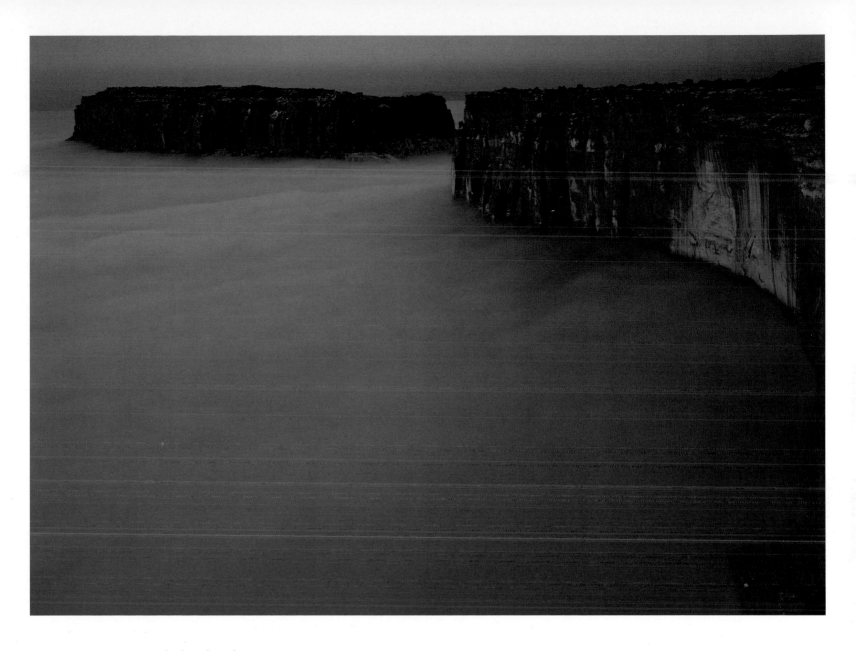

Dawn, Junction Butte, Canyonlands Park, Utah
This was a difficult exposure to figure, with a wide and odd
contrast range. When the film was developed, the best shots
turned out to be the sheets that were one stop over my selected
exposure. The lighter transparencies were more delicate, best
demonstrating the ethereal light on display.

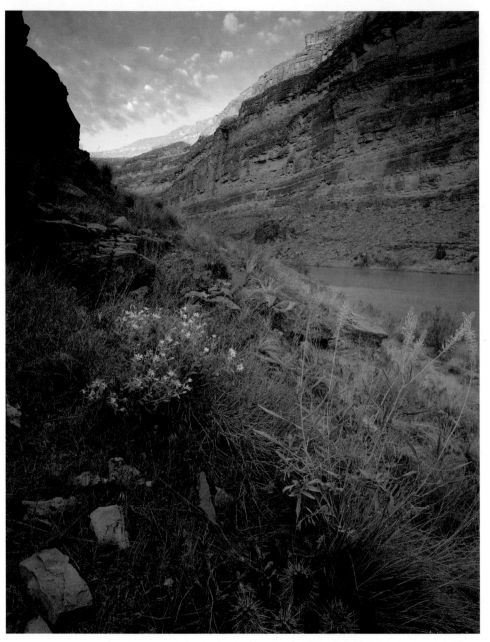

Focus

There are innumerable focus techniques and every photographic approach has one that will work best. Focus is a basic mechanism of photography, easily understood and simple to apply. These techniques run a wide gamut, from a total field of sharp focus – often applied in classic landscape – to the use of soft focus.

The focus plane works on a simple precept. When a lens is focused on a certain point in the field of view (called the point of focus), the zone of sharp focus will carry one-third of the distance towards the camera, and two-thirds beyond the point of focus. The depth of field (the distance between the nearest and farthest points which are in acceptably sharp focus) is dependent on the aperture used. A smaller f-stop (for example, f/32) will carry further than a large one, but will require more exposure time in compensation. A larger aperture (for example, f/4) will give a shallower depth of field, but will require less exposure time (a faster shutter speed) to admit the same amount of light.

In exposure, the aperture controls the amount of light reaching the film, while the shutter speed controls how long that light is exposed onto the film. When light is subtracted from one of these (for example, if the f-stop is closed down), there must be an equal and opposite reaction (the shutter speed must be slower to compensate for the reduced aperture).

San Juan River, Utah
Flowers are a classical foreground subject in landscape, working particularly well when the background is dramatic. This scene had an interesting mix of flowers and the rising sun laid a fine edge of illumination across the cliff. A neutral split-density filter controlled the contrast, holding detail in the sky. I focused just past the brightest yellow flowers, closing down to f/64 for the maximum depth of field.

If the main point of focus is eight metres from the lens, and an aperture of f/22 is selected, the focus will carry three metres towards the lens and six metres beyond the focus point, effectively giving a depth of field that covers nine metres. This distance will shrink as the aperture is opened (moving to f/16, f/11, f/8, and so on), and will expand as the aperture is closed down (moving to f/32, f/45 and so on). Understanding this concept will enable the photographer to control depth of field and this is a powerful tool.

Shallow depth of field, when used selectively and carefully, becomes a valuable technique and will enrich certain compositions. Portraiture often requires this approach, as a shallow focus on the subject's face draws attention and a blurred background does not distract from the main subject. This technique will also work with other photographic styles, and may even be applied to the occasional landscape. Placing one strong element in sharp focus and slipping the rest of the scene into softness will accent the main subject.

Complete soft focus is a difficult style but when applied to the proper composition can work wonderfully. Choosing the best scenes for this will take practice and this style won't often work. When well done, it will give a strong impressionistic feel to a photo. A portrait done with extreme soft focus will be dream-like, offering a misty view of the subject.

Exposure
This is the process of taking a photograph by admitting light to the film. The term also refers to the amount of light admitted, which is governed by the combination of aperture and shutter speed.

Cattails, Florissant Fossil Beds, Colorado National Monument
Selective focus can be a useful tool, especially when backgrounds are distracting. At a small park in Colorado, this drooping cattail presented an interesting composition but the background was busy, obscuring the shapes I was interested in. Opening the aperture narrowed the depth of field, throwing the background plants out of focus.

Motion

Movement is a powerful compositional tool and may be applied to almost any style of photography. One classic use of motion is with action scenes and this works well with a panning technique, following the main subject while employing a slow shutter speed. When done properly, the object in motion will retain some semblance of sharpness, while the surrounding space will blur. This will create the illusion of movement within a static medium, giving a strong feel of momentum.

In landscape photography several variations of this technique are available, most of them revolving around one shape remaining static while there is movement everywhere else in the scene. In most cases, this will involve either a combination of wind and vegetation, or rushing water and solid forms. This illusion, in all cases, will require a long exposure, ranging from half a second up to many minutes.

A rock surrounded by wind-blown grass offers a composition that mixes solidness with motion, as will a waterfall rushing over a rock ledge. Light on moving water will create interesting patterns, although these are difficult to predict in the final image.

Motion must be a selectively employed technique but it can add interest and occasionally improve a photograph. By carefully balancing stillness and movement within an image, a strong dynamic tension may be added to the composition.

Pillsbury Crossing, Kansas
Long exposures combine well with moving water, especially when other design elements are included in the composition. This small tree contrasts well with the curving waterfall, combining vertical and horizontal elements with motion in one scene.

OPPOSITE
Elm Tree, Flint Hills Prairie, Kansas
This image also offers the illusion of movement as the constant prairie winds have tipped the branches of this tree, giving mute evidence of their passing. This is a subtle use of motion, but is effective in this image, leaving little doubt in the viewer's mind which way the wind has been blowing.

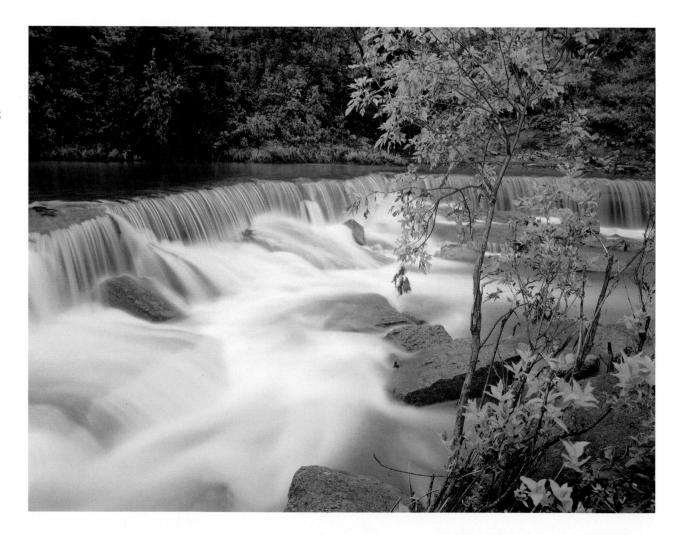

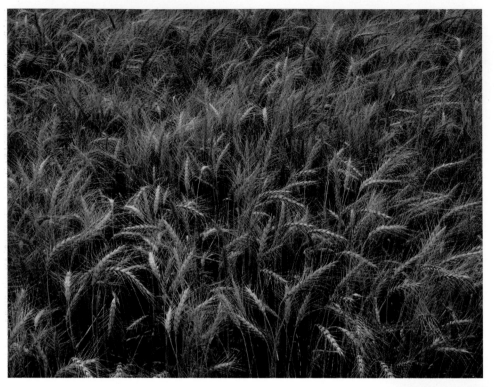

Here are two views of the same scene, one taken with a short exposure and the other with a one-second exposure during a burst of wind. This was an assignment for a book on Kansas and it was surprisingly hard to find a decent photo of a wheat field. While the publisher opted for the still version, I prefer the blurred one and consider it a more interesting image.

Wheatfield,
Rawlins County, Kansas
Short exposure

Blowing Wheat,
Rawlins County, Kansas
One-second exposure

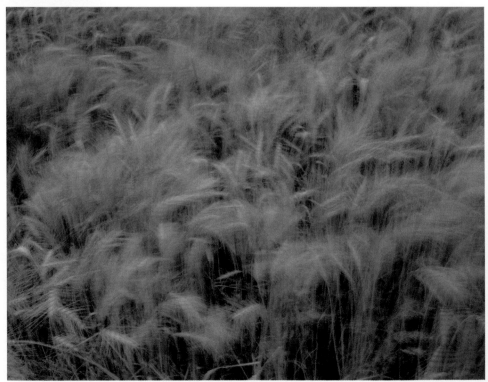

Sand Spit, Courthouse Wash, Utah
Light reflecting from moving water often creates wonderful patterns, particularly when mixed with a longer exposure. The afternoon sun was filtering through a stand of trees and a small spit of sand in the middle of this stream added the necessary ingredient to finish the composition. The tracings on the water seem to emanate from the tip of the sandbar and the long exposure worked well for this scene.

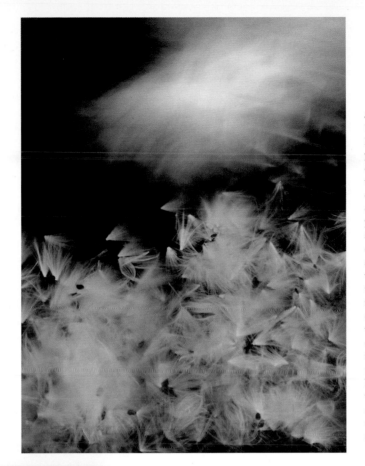

Seeds and Stream, Courthouse Wash, Utah
Motion and stillness, when properly mixed together, can create a strong sense of tension and this blending of elements will add interest to a composition. Some unknown plant had deposited these seeds on the stream bank and occasional wind gusts were slowly pushing them into the water. A small eddy (where the current was reversed, flowing upstream for a short distance) was swirling the white seeds around and a one-second exposure gave a fine combination of calm and movement to the scene. I have been working on a black and white portfolio centred on this small desert stream for 20 years and this was an odd but welcome addition to the collection.

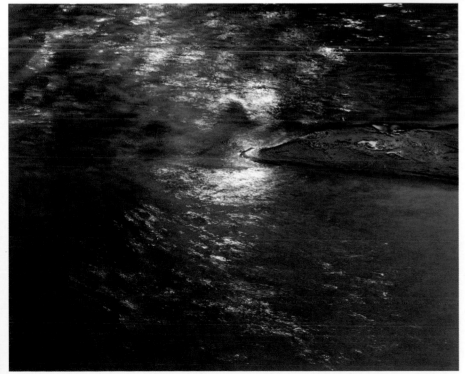

Depth of Field

This is one technical aspect that needs to be understood and mastered by all photographers. Depth of field is the distance between the nearest and furthest elements within the photograph which appear in sharp focus. It is determined by a combination of factors, including the camera format, the lens aperture, the distance between camera and subject, and the focal length of the lens.

A handy rule is that depth of field will extend one-third forward from the point of focus, and carry two-thirds beyond, as shown in the diagram below.

In general, the smaller the camera format, the greater the depth of field that can be achieved at any given aperture. The exception to this rule is the large-format view camera, whose rear tilt allows the plane of focus to be adjusted to maximize depth of field.

By focusing on infinity then tipping the rear of the camera back until the foreground comes into focus and combining this with a small aperture, an amazing depth of field can be achieved. Though this works best with a wide-angle lens, I have employed this technique with different lenses, ranging form standard up to telephoto.

As the lens aperture becomes smaller, the depth of field increases. A view camera will have much greater depth of field at f/45 than at f/16. A 35mm camera will have more at f/16 than at f/2. This, in practical terms, is the most useful means available to the photographer for controlling the extent of focus carry. How far the various apertures will carry can be learned though experience, although many SLR lenses have a depth of field preview feature which closes down the aperture as you look through the viewfinder.

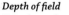

Depth of field
This chart shows the varying depth of field that will occur with different aperture settings. By focusing at a certain point in the scene, the depth of field will carry forward from that point approximately one-third, and will carry past it approximately two-thirds. The amount of distance these fractions will cover will depend on the aperture, as marked in the diagram.

Focal Point

1m (3ft) 3m (10ft) 6m (20ft) Infinity

Camera

Depth of field at f/32

Depth of field at f/16

Depth of field at f/5.6

Many 35mm lenses also have a depth of field chart on their barrel and these are generally accurate. A tripod allows the use of smaller shutter speeds, permitting a smaller aperture to be used. For hand-held work, a faster speed must be used (1/60 sec is the slowest speed most people can manage with a normal lens on a 35mm SLR) with a correspondingly larger aperture and smaller depth of field.

The greater the distance between camera and subject, the greater the depth of field for any given aperture. For extreme close-up or macro photography, depth of field may be measured in millimetres.

Depth of field is heavily affected by the focal length of the lens. A wide-angle lens gives inherently greater depth of field than a standard lens, while a telephoto offers a very shallow depth of field combined with a flattened perspective. The near–far style of composition generally requires a wide-angle to carry the focus, while distant compositions will call for a longer focal length.

Weed and Grasses
These are two examples of depth of field, with one displaying very shallow focus and the second demonstrating deep focus. The top photo was shot at f/4 with a 28mm lens on a 35mm camera. The point of focus was set on the middle section of the long weed and this is the only part of the scene that is sharp. The bottom photo was set up exactly the same, with the focus point still on the centre section of the long weed, but with an aperture of f/22. The smaller aperture has carried the focus throughout the entire scene, creating an entirely different composition from the exact same set-up at a larger aperture.

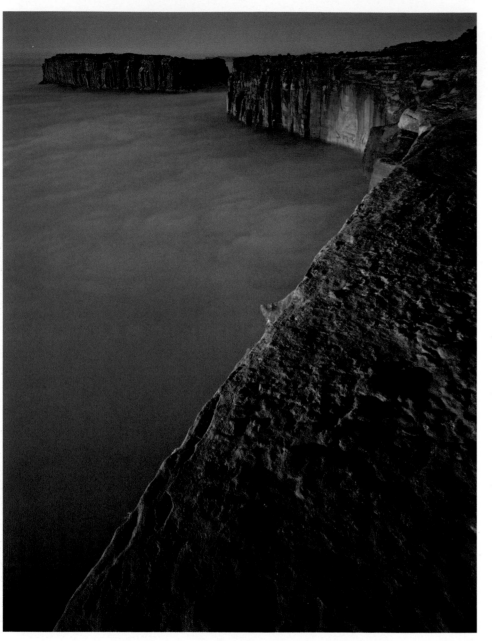

Aperture and Shutter Speed

Aperture and shutter speed are key controls for film exposure and the relationship between them is reciprocal. Understanding this balance is necessary in order to use the Zone System, but it is a relatively simple methodology. The aperture (also known as an f-stop) controls the amount of light that passes through the lens, while the shutter speed controls the duration of time that light is exposed onto the film.

Everything involved with these controls is done in halves and doubles, as a one f-stop change either cuts the light in half or increases it by a factor of two. This is also true with shutter speeds, as a jump to the next faster one cuts the duration of light in half, while a drop to the next slowest one will double it. Both are standardized and the list on the opposite page is the norm for apertures.

Using the sweeping cliff, this image is a variation of the thirds technique, only instead of that fraction it is divided in half, with a diagonal line running from the bottom left to the upper right corner. This can be a difficult style to use, as one of the axioms is never to divide a photo in half. In this case, however, the juxtaposition of rough rock and gentle fog works well, in large part due to the various textures involved.

Junction Butte, Canyonlands National Park, Utah
This scene required a long depth of field and I closed the aperture on the wide-angle lens as far down as possible. At f/45 there was scant light passing through the lens and a long exposure (four seconds) was required to counterbalance the small aperture.

f/2.8 — This is wide open and is usually the largest f-stop. While it will allow more light through the lens, it will give very shallow depth of field, severely limiting how far the focus will carry.

f/4 — This aperture will allow half as much light through as the previous one. The larger the number, the smaller the opening. It will give a slightly deeper depth of field.

f/5.6 — This is the beginning of the mid-range apertures and has cut the amount of light in half. The depth of field is expanding, although it still doesn't carry very far.

f/8 — This is the middle of most 35mm camera apertures and has again cut the light by half. The focus will be starting to carry longer.

f/11 — The beginning of the upper end f-stops, the opening in the aperture is fairly small, giving a decent depth of field.

f/16 — The light, once again, has been halved, allowing for a greater depth of field. With each corresponding closure of the f-stops, more light is being taken away, and this must be made up through the shutter speeds. Each time the aperture is closed down one f-stop, a correction must be made by altering the shutter speed, allowing more duration of light to reach the film.

f/22 — This is the upper end on many lenses (it is the smallest aperture), and will give a good depth of field. The opening is quite small, allowing a small amount of light to hit the film, but increasing the focus carry exponentially.

f/32 — The amount of light has again been halved, giving a deep focus carry (but requiring a slower shutter speed).

f/45 — An extremely small aperture, generally only found on view camera lenses. The depth of field is extreme.

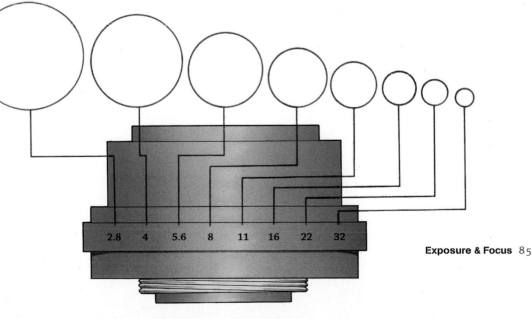

| 2.8 | 4 | 5.6 | 8 | 11 | 16 | 22 | 32 |

Aperture
The size of the opening in which light passes through the camera or enlarger lens. It is controlled by an adjustable diaphragm.

Lens aperture
The smaller apertures have larger f-numbers (f/16, f/22, f/32) and give the greatest depth of field. The larger apertures have smaller f-numbers (f/2, f/2.8, f/4) and produce a limited depth of field.

Basaseachic River
This was a very difficult photo to shoot but the result exceeded my expectations. The long exposure added to the mystery by blurring the water. While this is a strange composition, relying on a bright highlight as a base to the image, the forms and tones combine well and the oddness appeals to me. The small pool of water nestled on the top of the arch adds a nice small highlight and the distant sunlit ridge holds interest into the upper section of the photo.

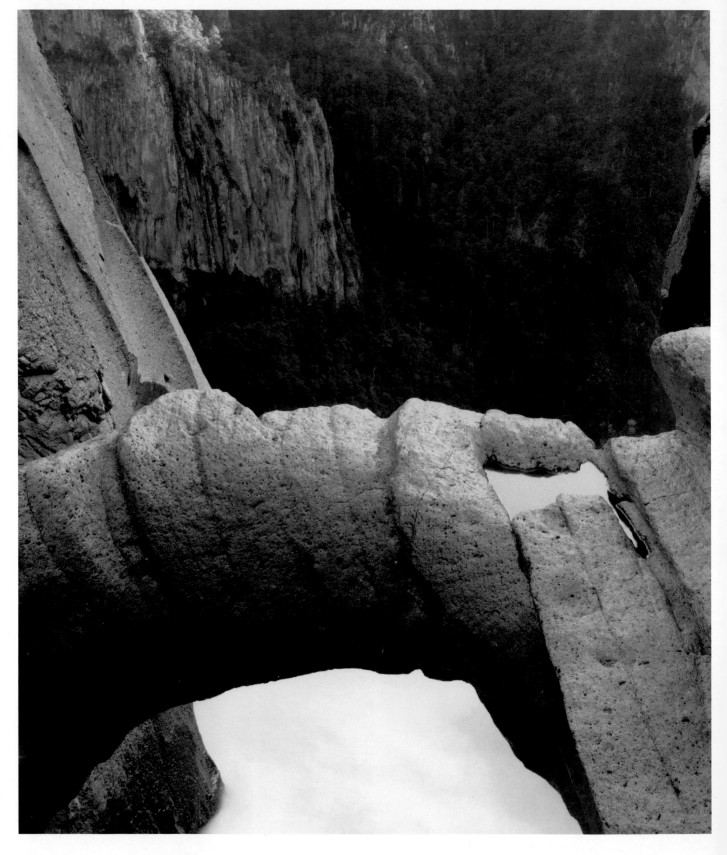

Up to Speed

The following is a list of the standard shutter speeds. While aperture settings are always found on the lens barrel (as the actual aperture mechanism is located between the glass elements within the lens), shutter-speed controls are usually found on the camera body.

The exception is view camera lenses, as both controls are combined, with each lens mounted on a shutter. When using these lenses, the aperture must be wide open to focus, and then closed down for the actual exposure. Most SLR cameras will do this automatically.

UNDERSTANDING SHUTTER SPEED

1/1000sec — This is generally the fastest speed found on cameras and requires an opened aperture to compensate for its quickness.

1/500sec — The duration of light going through the shutter has doubled, requiring a one f-stop closure to give an equivalent exposure.

1/250sec — Again, this is allowing twice as much light through as the previous speed.

1/125sec — The light reaching the film has doubled from the previous speed, and the aperture would now be closed down three f-stops for the equivalent exposure at 1/1000th.

1/60sec — This is the slowest shutter speed that most people can use while hand-holding a SLR camera with a standard lens, and still getting a sharp negative. With a reasonably fast film (ISO 400), a fairly small aperture can be had with this speed.

1/30sec — Twice the duration of light is now hitting the film, but this speed is too slow for hand-holding and a tripod is required from here down through the remaining speeds.

1/15sec — Smaller apertures are required as the duration of light is increased.

1/8sec — These slower speeds will require a steady subject, unless you want blurring of any motion in the scene.

1/4sec — Small apertures can be used, as the small amount of light they allow is being counterbalanced by the slower shutter speeds.

1/2sec — Near the bottom of the speeds, deep depth of field can be achieved.

1sec — Often the slowest preset shutter speed available, extreme focus carry is possible.

Bulb — This is the shutter setting that allows for exposures longer than one second. With this setting, the shutter will stay open as long as the cable release is held down.

For speeds below 1/30sec, a cable release should always be used, as depressing the exposure button without it will cause vibration, affecting the sharpness of the negative.

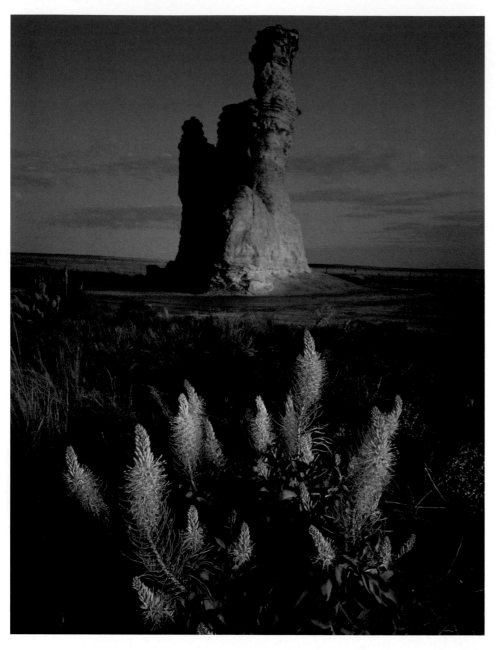

Getting the Balance Right

The relationship between shutter speeds and apertures is reciprocal, and when one is changed it requires a corresponding correction to the other. If the aperture is closed down one f-stop (for example, from f/16 to f/22), the shutter speed must change to allow more light through (for example, from 1/125sec to 1/60sec).

This reciprocity will hold true across the whole range of possible exposures and will be easy to understand if you remember the halves and doubles rule. When light is halved through one control, it must be doubled with the other: f/8 at 1/60sec is the same exposure (the same total of light reaching the film) as f/11 at 1/30sec. By closing down to f/11, the light has been cut in half, therefore the shutter speed must be changed to 1/30sec to compensate.

The key to understanding the relationship between shutter speeds and apertures is that the totality of light reaching the film is controlled by adjusting these controls, and that the smaller the aperture, the more focus will carry through a scene. The balance must be that the shutter speed will be slowed down to make up for the light lost by closing down the aperture.

Prince's Plume, Castle Rock, Gove County, Kansas
While photographing for a colour book on the state of Kansas, I became determined to capture a decent photo of Castle Rock, a rare spire in the western badlands. Arriving at the rock one spring day, I was excited to note a blooming clump of prince's plume at the base of the rock. On the third morning there, the incessant wind finally stopped during sunrise. With the extreme near–far aspect of this composition, a deep depth of field was required. With scant minutes to set up, figure the exposure and shoot film before the wind began again, I only managed to shoot one sheet of film. Before I could reverse the film holder, a stiff breeze began, hopelessly moving the flowers. This scene needed a perfect balance of shutter speed and aperture, both to minimize any movement within the yellow flowers and to carry the focus from the foreground through to the rock.

Infrared Film

Compared to traditional silver halide film, infrared offers a very different perspective. Anything that is reflecting and emitting infrared light will translate as a highlight, while anything that has absorbed this part of the light spectrum will print as a darker tone. Foliage is a strong emitter of infrared and always ends up as a highlight. Tree trunks and water don't reflect this light and will print as darker tones. Clear skies will tend to go deep black.

This film is notoriously hard to handle and must be exposed through either a deep red or an opaque filter. Figuring ISO and exposure is largely a matter of guesswork and development is also difficult, relying on trial and error, with the emphasis on error.

During college I made an infrared portfolio on trees for an advanced studies class. While I enjoyed putting the portfolio together, I came to dislike the film, considering it too finicky. I experimented with several developers and never really found one that was reliable with this difficult film. Among its many eccentricities, infrared should always be loaded and unloaded in total darkness – and this is true even with 35mm.

As long as the negatives have good tonal information it should be possible to make a decent print by using the split-contrast printing method and adjusting the two base controls to fit the infrared. The directions that come with Kodak Infrared should be followed, but with serious reservations. I began with these and gradually moved past them, developing my own methods. Of course, this has been my standard technique for photography, as I have never been very good at following directions.

Oak Tree, East Texas
This was the centrepiece of my tree portfolio, and was my best-selling print for several years. By exposing infrared on an overcast day, the dark shape of the trunk was emphasized, while the clouds, foliage and grasses went towards the upper scale.

Juniper, Park Avenue,
Arches National Park, Utah
**During those magical few
minutes as fog is slowly burning
off, distant objects slowly
coalesce into view, adding a nice
sense of mystery to any scene.
During a rare early morning
fog at Arches National Park I
focused a horizontal frame on
this dead juniper, knowing that
there was a large sandstone
monolith behind it, wreathed in
the fog. As the sun warmed the
air, the far rocks began to appear
and I quickly exposed several
sheets of film.**

**During a clear sunrise this
scene would have been rather
mundane. Using the clearing
fog as a compositional tool
introduced a sense of the
supernatural and vastly
improved the transparency.
Burning fog requires quick
camera work but can add a fine
element to any image.**

The Zen of Technique

Every photographer should, in my heartfelt opinion, gain a certain proficiency in technique and must have decent control over their materials. Basic camera control, understanding the relationship between apertures and shutter speeds, and knowing how to use and control focus – these are basics that can't be skipped. Being able to expose properly and develop film for the required effect, and mastering the follow-through of making a good print, are also important skills. After stumbling through the maze of technique involved in black and white, there comes a point where the panacea of technical ability must be released. This is a hard thing, akin to a toddler taking their first steps.

After seeing Minor White's prints, and finally understanding the Zone System, for several years my photos were high-contrast imitations of White's work. The level of control was amazing, and all of my prints were designed to show this off. It was years before I realized what was happening, that my work was only about displaying technical prowess. Even more time passed before I began to develop my own style and was able to release the crutch of technique.

Technique is a conundrum as it is both an important and requisite part of the process, but it can also – if improperly emphasized – become a terrible impediment. The key is to adapt those aspects that are needed for your personal photography, discarding the excess, useless knowledge along the way. In my experience working past technique is absurdly difficult. However frustrating it may be, this passage is important and will unfold at its own pace.

**Four:
Colour & Light**

Quality. Direction. Colour. Weather.

COLOUR AND BLACK & WHITE ARE VASTLY different processes, both have unlimited possibilities and either can be used to create exciting imagery. The photographer simply needs to have an empathy with the medium being used and an understanding of the techniques required to create powerful and lasting images.

The basic elements of colour and black and white are similar, with both relying heavily on compositional shapes. A monochromatic print combines these shapes with tones, while colour combines shapes with the various hues within the image. When a black and white print is stripped to its bare essence it becomes an interplay between shapes and tonal values. The relationship between these tones – the juxtaposition of similar or different shades – is the skeleton of a print. Without this support, the image won't be able to hold together. This delicate interplay between tones will elevate a print, and the balance between greys, blacks and whites is the hallmark of a fine monochromatic photograph.

When a colour image is stripped to its essence, it becomes an interplay between shapes and hues. The rainbow of tints contained within colour transparencies is impressive, and can be sharp-edged and strong, or soft and pastel. This relationship between shapes and hues is the backbone of a colour image.

While the contrast of transparency film is technically limited, the workable range of hues can widen this latitude enormously. Pastels can carry an image of high contrast, in effect stretching out the usable contrast range. These edges of contrast tend to blur in colour and provide a useful compositional tool.

La Gorce Arch, Lake Powell, Utah
The creation of Lake Powell in southern Utah flooded some of the world's more fantastic landscapes, but a few places survived. La Gorce Arch was high on a sandstone wall, above the lake waters, and stayed above the unfortunate inundation. Visiting the arch in the middle of the day, I decided to take a grab shot, making the best of the harsh light. The reflections on the water help this composition and, much to my surprise, it has sold several times.

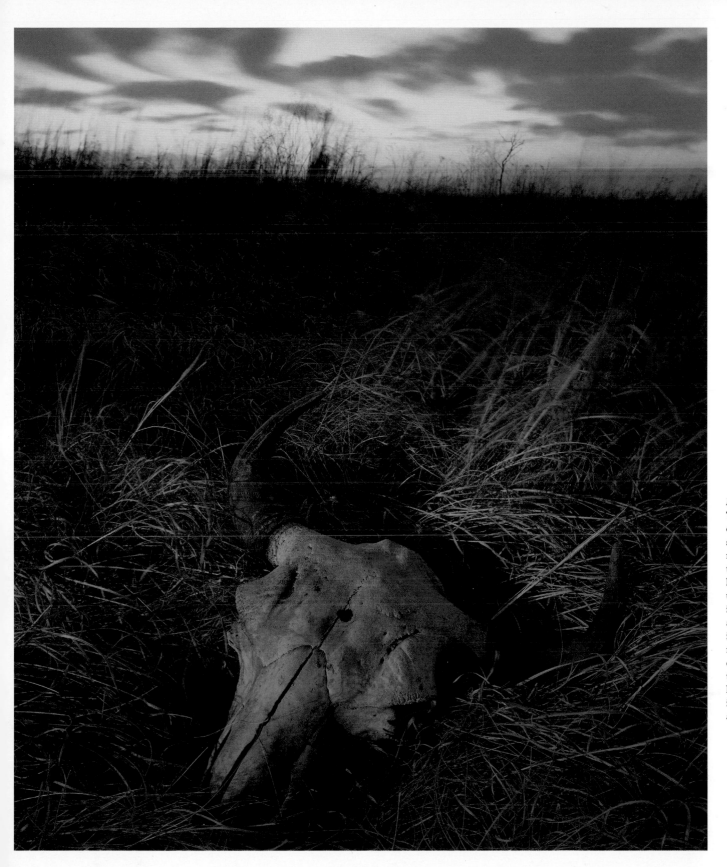

Bison Skull, Konza Prairie, Kansas
This is a skull that the manager of Konza Prairie gave me, and I spent a fruitful afternoon and morning playing with it. Using the bright post-sunset sky, I laid the skull in the grass, and used my truck headlights to illuminate the scene. Headlights are usually some type of incandescent light and, as a result, tend towards the red end of the spectrum. The photos I took of the skull with natural light were far better, but this is an interesting example of artificial light.

The Quality of Light

Light is an incredibly powerful force and nowhere is this more evident than in photography. The range and types of light are infinite, with each subtle variation having a distinct character. This quality of light will play an important part in selecting a composition, both in colour and monochrome.

Pre-dawn light is exquisite, giving a full, pastel range of hues, simultaneously softening contrast. As the night is dispelled, before the first sunbeams flow over the horizon, a constantly brightening spectrum of richly gentle light is on display.

For certain scenes this will be the best time to shoot, in particular those images that require a soft contrast that will best be served by quiet shadows and pastel colours.

This type of light can sometimes be effective in black and white, allowing the tonal range to be stretched and giving a final print of soft contrast but with a long and luxurious series of greys. This light is very flexible when applied to a monochromatic print, allowing a high degree of contrast control during printing.

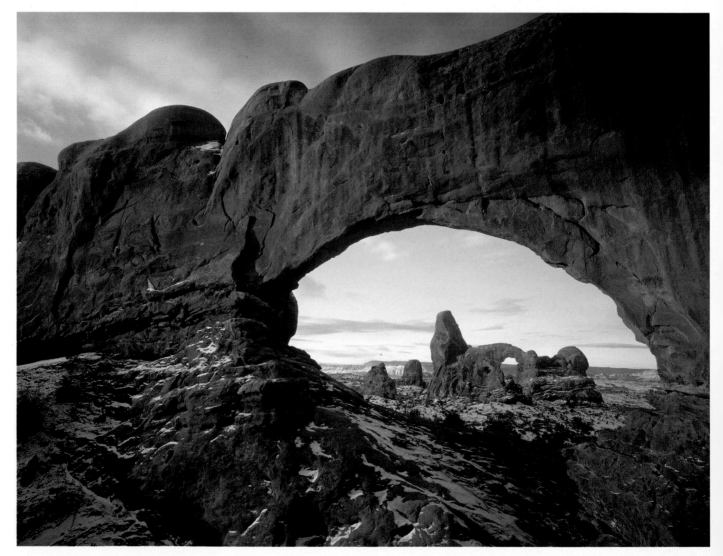

North Window, Turret Arch, Arches National Park, Utah
This is a classic view in Arches National Park. After a rare snow I drove up before dawn, selected a composition and waited. As the sun lit up North Window, there was time for two exposures before a distant cloud blocked the light. This is classic dawn light, as well as a strong example of the frame within a frame compositional style.

Pre-dawn also offers the possibility of vibrant eastern skies, particularly when there are interesting clouds over the horizon. As the Earth rotates, eastern clouds will begin to light up, first offering a light pink pastel, gradually gaining intensity, eventually becoming an intense red. This angle must be approached with care, and will usually need some kind of interesting foreground, one that will work in silhouette. Pre-dawn light is often ignored but can generate wonderful possibilities.

As the sun crests the horizon, the light enters the magic minutes. For several minutes after sunrise there is a rich, glowing light and landscape photographers often take advantage of this time. Long shadows are thrown and surfaces pick up a strong, warm glow.

Shooting into the sun at this time is difficult and you will need some kind of object to block the direct sun, as well as to throw long shadows towards the camera. When done well, however, this variation of backlighting can be hard-edged and vibrant.

During overcast days, when breaks appear in the cloud cover, spotlighting can occur. When shafts of sunlight flash through these cloud breaks, small sections of the landscape will be beautifully lit. This type of light is hard to predict but when the situation is right, it can be luminous.

Black Rock, Colorado River, Colorado
Above one of the major white water canyons on the Colorado River there is a geological oddity, a place where ancient schist has been forced up along the banks of the river. This rock is only exposed on the surface in a few places around the Earth. For countless aeons, water has flowed over these rocks, creating some abstract erosional patterns. Rising early, I set up and photographed 30 minutes before sunrise, making good use of the flat illumination. Because the east was behind me, the pre-dawn light was perfect, giving a soft, rich feel to the rocks. The spectacular highlights contained within the black schist added an important element and the grey background river finished the scene.

Leonides, Poison Spider Mesa, Utah
During the Leonides meteor showers, I scouted out some prehistoric rock art that faced the southern sky. I set up the 4 × 5 and, using a hand-held floodlight, lit up the cliff and rock art. This was a two-minute exposure, with the lens closed down to f/45 for good depth of field. After making this first exposure I focused on infinity, opened the aperture up to f/5.6, and made a second, three-hour exposure. During this time, one meteor flashed through the sky, angling across the star trails.

Midday light is harsh and difficult to work with. There are occasions, however, when this hard-edged illumination will enhance a subject. Dramatic photojournalistic scenes, for instance, may be given an immediacy in this light, a sense of urgency that wouldn't appear in softer illumination.

When cloud cover forms during the day, certain photo opportunities appear. This flat light gives a smooth illumination and can work well with some scenes. Environmental portraits will work with this type of light, as can some architectural scenes.

As the end of the day approaches, once again there are several minutes of magic light. Sunset light differs from its dawn counterpart, having a sharper edge and tending to have a deeper saturation.

After sunset there is a variation on pre-dawn light, with a short period of soft illumination. Post-sunset light seems to offer less time than pre-dawn and doesn't have the range of hues offered by the morning version. Post-sunset will also occasionally light up western clouds, and again some type of foreground silhouette is needed. A black, flat horizon line with bright clouds above it will lack compositional interest.

Night photography offers strong possibilities but this type of image must contain certain elements. Water is a wonderful reflective surface and can be used to great effect at night. The long exposures required also create star trails and when combined with other elements will add interest to a photograph. Fill-in illumination can also be used, either with a flash (used either once or in multiple bursts) or with some type of floodlamp. Lighting up a foreground object and then leaving the shutter open to catch star trails can make an eye-catching composition.

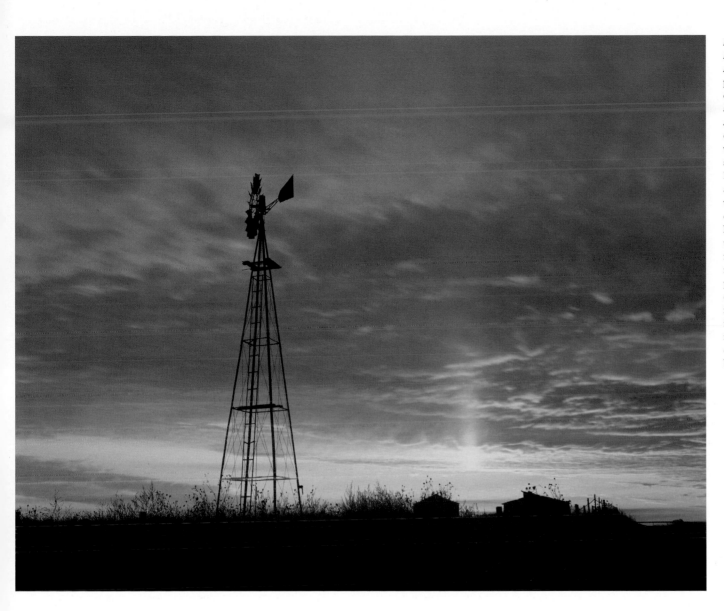

Post-Sunset Light, Windmill, Kansas
After a productive afternoon of photography on the High Plains of western Kansas, I packed up and went looking for a motel. Although it seemed that the evening photo opportunities were finished, the western sky suddenly began to light up and I began a desperate search for a composition. Noticing this windmill by the road, I pulled over and set up a quick shot. A last lone sunbeam shot straight up from the horizon, lasting for less than a minute, and I managed a few exposures. This post-sunset light always happens quickly but it can be lovely. This is one of those grab shots, taken in a flurry with no planning, but it has been popular, gracing the cover of a Kansas book as well as being in several calendars.

The Direction of Light

An often overlooked aspect of photography is the angle and direction from which the light is falling upon any given scene. This is of paramount importance and will either aid or ruin a composition. While it is a seemingly simple matter, there are many nuances that should be considered.

FRONT LIGHTING

When the light source is behind the camera and falling directly on the subject this is called front lighting. This is the most common type of light used in photography, be it sunshine, strobe or some other form of man-made illumination. By making slight changes in angle between the camera and the subject, shadows can be used to accentuate the main centre of interest.
This light will also brighten the subject, drawing the viewer's attention.

SIDELIGHTING

When the light source is at a 90-degree angle to the camera, throwing shadows off to the side of the subject, this is called sidelighting. With this type of illumination the shadows become more dominant and are an important element in the composition. In some instances the shadows will become the main subject. This type of light also changes dramatically with small changes of camera angle, alternating from front-lighting through the range to backlighting.

Slickrock, Courthouse Wash, Utah
This is a photo of a small section of sandstone that has been scoured by aeons of flooding, resulting in a marvellous edging and fluting. By moving the camera in close to this small area of slickrock, I have created a semi-abstract composition, giving some hints of the nature of the subject, yet holding a strong feel of mystery as well. This is an example of sidelighting. I used this angle to exaggerate the unevenness of the rock. By shooting at a 90-degree angle to the light source the ridges are enhanced and this illumination is suited to the scene.

BACKLIGHTING

When the light source is directly in front of the camera, this is backlighting. This is difficult to work with but when correctly used can add excitement to a photograph. A repeating series of shadows, for instance, can radiate from the same background object, pulling a viewer into the scene. Light reflecting off water will also add drama and will occasionally be the best angle for certain compositions. As with the previous types of light, slight angle changes will make large differences in the final photo. By using a background object to block the light from directly hitting the lens, flare will be avoided.

King's Creek, Konza Prairie, Kansas
Backlighting can work when there is water in the scene, as it will act like a reflector, adding highlights to the image. King's Creek is a lovely little stream that runs through Konza Prairie in Kansas and this photo was taken shortly after the dead winter grass was burned, with the lush green shoots coming up. The backlighting accentuates the rolling hills and the twisting creek adds an interesting highlight to this composition.

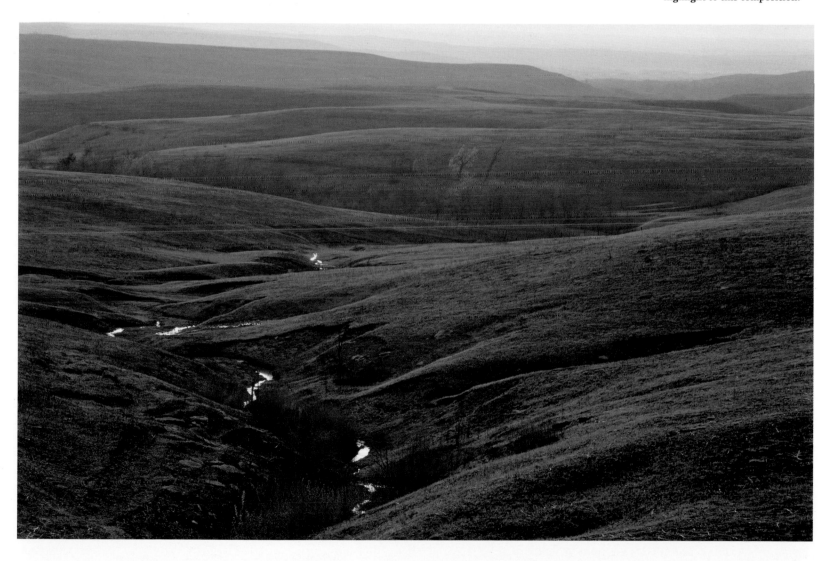

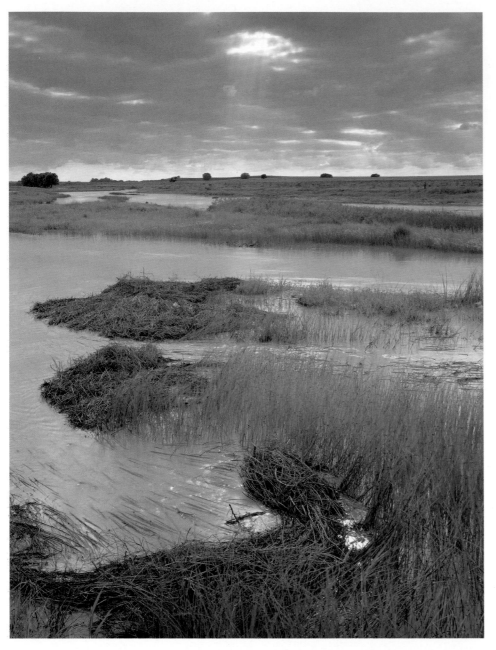

FLAT LIGHTING

When the source of illumination is shaded by something, as with overcast clouds, or in open shade during a sunny day, this gives flat light. This is a very malleable form of illumination and can be used for many different types of composition. Even with this source, angles are very important. Despite being shaded, the light still has a particular direction and this must be taken into account when making an exposure. Shooting towards the source will give a very flat contrast, while shooting away from it will provide a more interesting illumination.

SPOTLIGHTING

Spotlighting is an unusual but often impressive type of illumination. It happens most often when a heavy cloud cover has periodic openings, allowing the sun to slide some beams through and highlight small sections of the landscape. While it is difficult to predict, and requires a large degree of flexibility from the photographer, when conditions are propitious there will be good opportunities.

Smokey Hill River, Kansas
This is a small river in western Kansas and it rarely has any water running down its course. After a spring storm, the Smokey Hill briefly flooded and I set up along the bank to catch this unusual event. There was high cloud cover, and a small break allowed some sun to shine through, giving a nice illumination to the scene. The delicate spotlighting was the final touch for this photo, adding allure to the muted overcast.

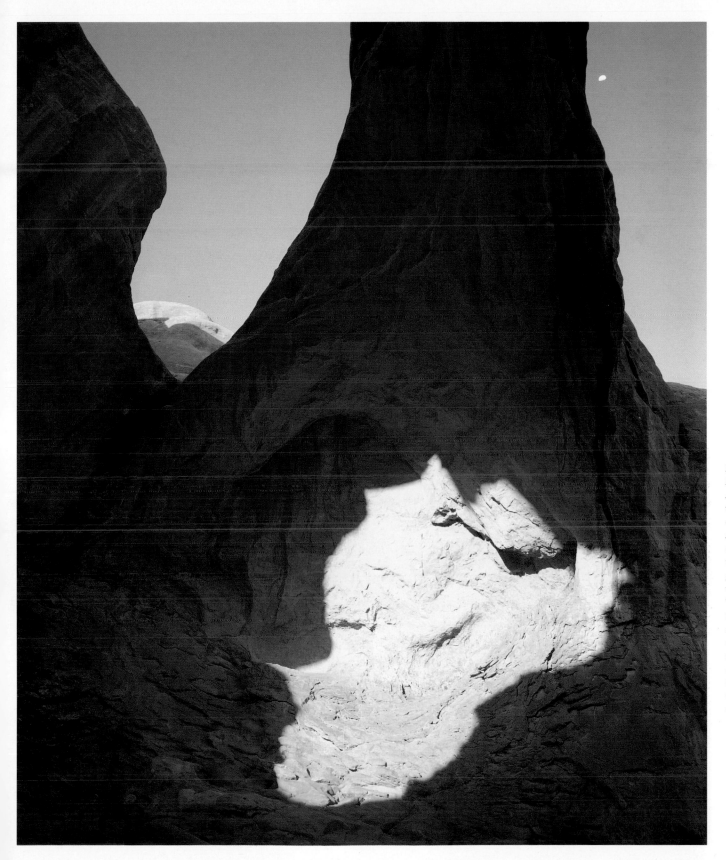

Double Arch, Arches National Park, Utah
Arches National Park has the world's highest concentration of natural arches and Double Arch is a dramatic example of these spans. Looking for a unique view, I scrambled around, gradually arriving under the western half of Double Arch. The setting sun slowly began to shine through the western arch, throwing a glowing circle onto the base of the opposite arch, and the small rising moon completed the shot. This is a type of spotlighting and was technically difficult as the contrast range was huge.

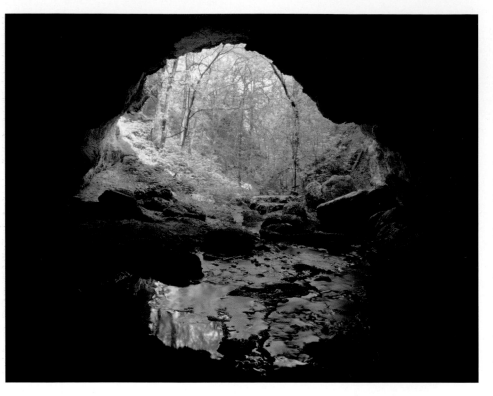

Pope Cave, Kansas
Shooting from the darkness into bright light is a workable technique, as long as you are happy for the shadows to be pure black. Looking for an angle on Pope Cave in western Kansas, I decided to shoot towards the opening, into the midday sun. Six rattlesnakes were enjoying the cool entrance to this cave. Using a long stick, I carefully chased these irritated reptiles out of the cave. The small stream provided a fine reflection, mirroring the shape of the entrance.

The Colour of Light

The colour spectrum of light is amazingly wide and this will have a large degree of influence on any given scene and composition. The range runs from extremely warm and red to the opposite end, where the colour is blue and cold. Paying attention to the appearance of light will edify an image and, conversely, ignoring the colour of light will be detrimental.

As the eastern sky begins to edge towards dawn there is a strong and steady shift from dim, blue light into a slowly warming colour. As the illumination gains in strength the light begins its inexorable slide from cool into the coming warmth of sunrise. This is a lovely period for the colour of light, offering a steady change.

Sunrise offers the warmest natural light, bathing any chosen scene in reddish-orange light. This effect will be the most extreme when shot from a 180-degree angle from the sun, with the illumination coming directly behind the camera.

As the sun rises, the colour of light will gradually begin to change, slowly entering a yellowish phase. At its zenith, the sun becomes brutal, leeching colour out of the landscape, putting a sere yellow tint into any scene. This harsh colour will hold while the sun traverses the sky, until it begins to approach the western horizon.

At sunset, the colour of light begins to shift towards the red, although not usually to the degree offered at dawn. Again, this warmth is greatest at a 180-degree angle to the sun.

After sunset, there is a mellow period of transitional light, with the colour slowly moving from warm into a cooler blue. This period is lovely and may be used to great advantage, allowing the photographer a wide palette of colour with which to work.

As the western horizon darkens, the light perceptibly shifts to the cold blue end of the spectrum, a difficult colour to work with but one that offers some possibilities. The long exposures required during this time also affect the colour of the light, moving it even further into the cool end of the spectrum.

Overcast skies tend towards coolness, but in a more neutral sense of colour. This flat illumination tends towards the grey and will be difficult to manage in colour. This washed-out effect can be better applied to black and white, where the lacklustre contrast may be boosted during printing.

Artificial light also covers a wide range and may either be shot as is, taking advantage of the colour of the source, or filtered to remove any colour cast, giving the image a neutral balance. Fluorescent bulbs possess a strong greenish-yellow colour and tend to look horrid in photographs (unless this is the photographer's desired effect). Incandescent light sources tend towards the red end of the spectrum and this result can also be overpowering. There are several filters available to control these shifts and these are often used in interior architectural work.

Gillicus in Xiphactinus, Sternberg Memorial Museum, Kansas
Artificial light is hard to work with as the colour will shift either to cold or warm, depending on the source. This fantastic fossil was receiving light from several sources, including fluorescent, incandescent and a small amount of natural window light. This was a confusing mixture and figuring the colour balance was hopeless. Taking an average meter reading, I made several exposures. The final film was surprising, and the various light sources seemed to balance out.

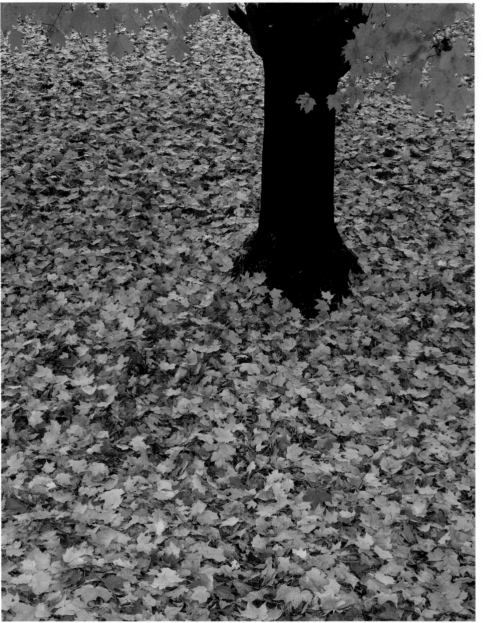

STRONG AND MUTED COLOURS

As well as having a broad spectrum, colour runs a wide gamut in terms of intensity. This covers a range from muted and subtle, across the spectrum to a vibrant, almost overpowering saturation.

Muted colours are often lovely and will work well with a number of compositions. These pastels help to increase the contrast range and are particularly effective in colour scenes. Still-lifes benefit from soft lighting, as do portraits. When a photo contains a wide spectrum of muted colours there is a strong balance and this technique can be very effective.

As the pastels give way to stronger colours, contrast increases, which will be good with particular scenes. The light transition from pre-dawn into sunrise is a good example of this shift, where the colour slowly gains in intensity and shadows become sharp-edged.

As the light continues to climb in intensity, the muted aspect disappears and colours become harder, both in saturation and edge. When the spectrum becomes this harsh there are few compositions that will be successful. This light requires a scene which will benefit, one that needs this hard-edged illumination. An example of this might be some types of photojournalism, where the edginess of the light emphasizes the subject matter.

Maple, Ohiopyle State Park, Pennsylvania
Ohiopyle is my favourite state park in Pennsylvania and it always offers rich possibilities. During an autumn trip the colours were magnificent and this particular maple caught my attention. The carpet of fallen leaves provided a perfect counterpoint to the dark trunk and the single leaf highlighted against the tree completed this composition. Taken at noon under heavy cloud cover, timed between passing rainstorms, the light was perfect. Diffused midday light provides a level, even contrast, and can be very effective in certain circumstances.

COLOUR AS SUBJECT

With particular compositions, when the colour within an image becomes extremely vibrant, the colour actually becomes the subject. Of course, the various shapes contained in the photo will always play a compositional part, but in certain instances, pure colour will carry a scene.

This technique should be used with care, as it can turn into a transparent attempt to manipulate the composition. The rule of thumb, as with all compositional styles, is to be subtle.

For several years I was working on a project to document the tallgrass prairie. There are only small pieces left of this ecosystem, but the Inland Sea once ran from Texas up into central Canada. Locating these small patches required serious detective work and it was always gratifying when a decent photo came from these searches. Tracking down a prairie preserve in Canada, I found and photographed this lone lily rising from the grasses. The bright flower stands out from the muted green grass and is a strong centre of attention.

Western Red Lily,
Tallgrass Prairie Preserve,
Canada
There is a compositional technique where one relatively small area in the image becomes the dominant centre of attention, drawing the viewer's eye immediately. In colour, this is achieved by placing a brightly coloured shape in a scene of generally dull hues. In black and white, the effect is reached through a small highlight surrounded by darker tones.

Black and White

The colour of light will have little effect on black and white photography, but the intensity of light will play a large role. There are many contrast controls available for monochromatic film but the type of light will strongly affect how the final image translates onto the print.

Soft lighting works well, as the tonal range may be adjusted to fit the illumination of the actual scene. A long, smooth range from black, through a long and gradual grey scale, into the upper white zones, will enhance most black and white images. This type of print scale is easier to achieve when the light is softer, although even harsher light may be spread out in the negative and print.

Changing from colour to black and white, shifting mental approach, can be difficult. The changeover requires a certain flexibility and adaptability. Altering vision, moving from seeing colours (and imagining how they will translate into the final image) into monochromatic (visualizing the grey scale, and how the scene will fit into it), can be hard, but will ease with practice. The ability to choose between the disciplines – to understand what kind of image will work best with which style of photography – is a skill and may certainly be developed.

As with colour, certain styles of illumination will work better with certain monochromatic scenes. Harsh light will give immediacy to a photo, adding a sharp edginess. Smoother and longer scales will come from angled or flat light, aiding many types of composition. Black and white landscape traditionally works better with angled light, which highlights the topography being photographed.

Juniper Snag, Park Avenue, Utah
A rare morning fog at Arches National Park created some interesting photo opportunities and this dead juniper tree gave me a fine foreground as a base for the composition. As the fog slowly lifted, the tips of the sandstone monoliths of Park Avenue were revealed, completing the image. Though I had to wait an hour for the fog to thin, the resulting photo was well worth the effort.

OPPOSITE
Frog Canyon, Utah
These little frogs were caught in a dry pothole and had long since died. My friend Chris Conrad discvered the dessicated bodies and showed them to me. They were down in a deep hole and I didn't see any photo possibilities. Moving the small frog carcasses to a nearby waterhole, I began to play with arrangements. Using the setting sun as a backlight, I decided on this set-up, emphasizing the long and odd shadows. This is an environmental still life, as it was shot outdoors with no light control, but is a definite arrangement and so fits the definition of still life.

Lightning Storm, Eagle Rock, Scotts Bluff National Monument, Nebraska

Scotts Bluff was a major landmark for the wagon trains during the huge American western expansion at the turn of the twentieth century. The tall cliffs meant rest and water and were an indicator of progress. I produce a Nebraska calendar every year and this small park has become a favourite subject.

Weather as a Compositional Enhancement

The old axiom 'Bad weather makes for good photography' contains more than a grain of truth. In many scenarios, poor weather can greatly enhance compositions.

As the rising sun burns off a fogbank there is a brief period of time when a scene is gradually becoming visible, and these few magic minutes can offer unlimited compositional possibilities. The rapidity of these opportunities requires quick camera work, but the possible rewards are great.

A heavy, unmoving vapour has a different enticement, imbuing everything it veils with a strong aura of mystery, offering hints without fully revealing the subject. Placing the camera close to the main subject, allowing the secondary elements to fall out of focus, will add interest to an image. This type of fog also offers the advantage of time, as it will generally hold for long periods.

Although difficult to capture on film, lightning can inject great drama into a photo and is a compositional element of much power. A mundane foreground becomes exciting when a bolt of pure electricity blasts across the sky. The best technique for this phenomenon is to shoot during periods of low-level light (evening storms work well), using a middle aperture (f/5.6 or f/8), making long exposures. It is virtually impossible to trip the shutter as the lightning occurs, as this would require superhuman reflexes.

Although difficult to work in, a strong rainstorm can be a wonderful compositional tool and photos taken during this type of weather seem to mute, becoming gentle and soft. A good umbrella is required, and dry footwear combined with a good poncho will also help. Rain discourages most photographers, but the difficulty is often worth the potential reward.

Storm light is an unusual phenomenon, where the sun breaks out from lowering clouds for brief instances, usually at dawn or sunset. The combination of low-angle light with forbidding clouds is strong, particularly for landscape photography. Shooting into the sun will exaggerate this drama, although pointing the camera in the opposite direction from the sun can also produce exemplary results. This is a choice – as with most composition decisions – that must be made based on each particular scene.

Almost any unusual weather condition may be used to enhance a composition, and although the possibilities may not be obvious, a patient contemplation can ultimately end with a good photograph. Watching a massive storm swirling around Eagle Rock, I pulled to the side of the road and quickly set up this composition (see the picture opposite). When the lightning began, the majority of strikes were unfortunately behind me, and uncomfortably close. Biding my time, I waited for the storm to swing over Eagle Rock. After sunset, a beautiful storm light was bouncing off the cliffs and the lightning was moving over the butte.

During the first exposure a powerful bolt dropped, giving me hope that it would be in the composition. Closing the lens and flipping the film holder, I began a second exposure. Glancing at the tripod, I was shocked to see Saint Elmo's fire dancing across the legs, looking like tendrils of blue flame. Never having seen this phenomenon before, I took it as a sign and shut the camera down, quickly climbing into my truck's cab.

When the film came back I was pleased to see the lone strike on the first exposure. The second sheet was covered with electric blue lines, looking very much like Saint Elmo's fire.

Having the lightning drop across the right side of the frame was fortuitous and, when combined with the lowering clouds and the eerie light, made for one of my best storm photos.

My Darkroom

This is my darkroom, showing (from left to right) the print washer, and the first sink (which is there mainly to hold the washer but also to accommodate trays for making larger – 16 × 20 in and up – prints). Under the first sink is storage for powdered chemicals. The timer over this sink is for film development and is set here so it won't fog the film as it is tray-developed in the next sink. The container next to this timer has distilled water for film development.

The darker sink is my main work area and is 20 years old. After 17 years I had to recoat it with polyurethane varnish, but it has withstood much harsh use. On the shelf above it, the developing tank is for 35mm and 120 film, followed by chemistry: Photo-Flo wetting agent, HC-110 developer, stop bath, hypo-clear and selenium toner. The timer is for print development and is covered during film processing. To the right are various graduates and jugs used for mixing chemistry.

Over the sinks, a nylon string has plastic clothes pins for hanging film and a print-viewing light is set over the final water bath. The far left tray is the final water bath, the next two are for fixer, followed by stop bath, a dilute developer and, on the far right, a tray of straight developer. Mixed fixer and print developer are stored under this sink, as are the various size trays that aren't being used. The main safelight is mounted on the ceiling, and the exhaust fan is vented through the attic.

To the right of the sink, a long work table allows me to pile up whatever materials I am using in a session, including boxes of paper. The Zone VI enlarger is on the far end of this table and the auxiliary safelight is mounted on the wall. The small box is the variable-contrast control for the enlarger and the grain focuser is sitting on the adjustable easel.

The print timer is mounted on the wall next to the enlarger and, as I prefer to print sitting down, I have built a low counter to hold the enlarger. The tall shelving across from the enlarger is for print storage.

Next to these shelves is the print-drying rack. I have an abiding affection for good maps, and the ones on the darkroom walls are of places I frequently shoot and places that I hope to visit.

Film Exposure and Development

HC-110 is my favourite film developer and with different dilutions it can give a large range, whether the film needs to be pushed or pulled. This chart is old, but I have always found these times to be accurate. A personal ISO will need to be determined for each film and after that these times will be fairly accurate.

HC-110 TIMES AND DILUTIONS

	NORMAL	N+1	N+2	N-1
TRI-X	6	10	–	4.5
PLUS-X	4	5.5	10	–
FP-4	5.5	8	10	4.5
HP-5	6	8	11	4

Stock solution diluted 1+7 (times given in minutes)

	NORMAL	N+1	N+2
TRI-X	10	8	6.5
PLUS-X	8	6.5	5.5
FP-4	10	8	6.5

Stock Dilution diluted 1+15

The higher dilution makes possible larger cuts in development time and should only be used when a time cut is indicated. These are the times I have used for 30 years with Ilforc FP-4 film and they have always worked well. On those occasions when I have used a different film, this chart has still held true.

Dodging and Burning

These are subtle aspects of the print layering process, and must be done with a delicate touch. In the examples below I have purposely overdone the required dodging as an example of how overuse will appear in a print.

Dodging is the technique employed to lighten selectively certain areas within a print by withholding light during enlargement. It must be performed in the course of the two base exposures. I keep a simple set of tools at hand, all consisting of various sized cardboard circles taped to lengths of wire. The cardboard is cut from light but stiff stock, such as a manilla folder.

Burning is an equally important technique, and is always the last layering before the paper goes into the chemistry. As with dodging, I have a set of standard burning tools, all pieces of cardboard with holes of varying size. Burning adds density to selected areas and is generally used to bring highlights down. As with the previous method, I often make custom burning tools, depending on the particular negative's requirements.

Tools for the job
These are my basic tools for black and white print manipulation. The sheets with various size holes are for burning (adding light to select areas within a print), and the circles mounted on wire are for dodging (subtracting light from small areas within an image during printing).

LEFT
Deer Creek, Version one
Here the foreground shadow was printing too dark. Making a long and narrow dodging tool and attaching it to a straightened paperclip, I dodged the shadow, attempting to lighten it. But I over-dodged, causing this odd ghosting in the circled area. This is the classic telltale for bad dodging and is mute evidence that the tool was held stationary over the paper for too long.

RIGHT
Version two
In this print, the dodging tool was moved constantly during the soft-contrast exposure and the shadow density has been slightly lightened, without leaving any evidence. The detail has been accentuated without leaving any sign of manipulation and this step has definitely improved the image.

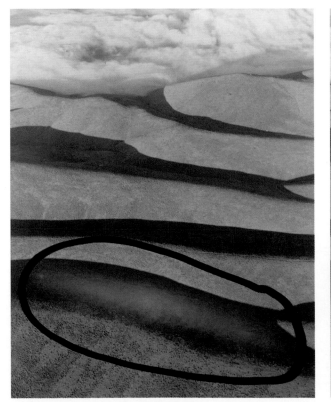

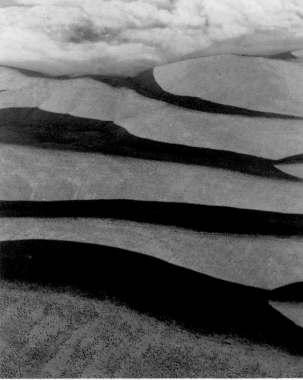

Extreme Manipulation

Although I generally avoid radical printing techniques, sometimes these methods can create interesting images. There is a definite art to combining different negatives into the same photograph. The standard method is to use a series of enlargers, each one set up with a different negative. By running the paper through the different enlarger stands and with adroit burning and dodging, some very interesting effects can be created. The wonderful and whimsical photographer Jerry Uelsmann uses this technique to make his mystical images and he is the undisputed master of multiple-negative printing. In his prints, the areas where the different negatives meet are so expertly blended as to be invisible.

Most people can't afford several enlargers but the same method can be applied – albeit with more difficulty – with a single enlarger. I have made a few multiple-negative prints and by carefully changing the negatives in the carrier, and with a lot of experimentation, some have actually worked. This demands some serious dodging and burning, as well as a ridiculous amount of patience. With practice, however, this technique offers a fun alternative to single-negative printing.

In the picture (right) the sky printed quite light and I dodged it all the way to white during the first exposure, exposing the lower 9/10 of the image. Leaving the paper in the easel, I replaced the first negative with an eclipse. Luckily, the sun was in the upper part of the negative and so I simply needed to blend the line where the two negatives intersected by placing it at the base of the distant mountains and blending the intersection with some artful dodging.

Many tries later, one of the prints came out of the fixer with a good blend where the negatives met, giving the illusion of a total eclipse over Lake Tahoe.

Eagle Falls, California

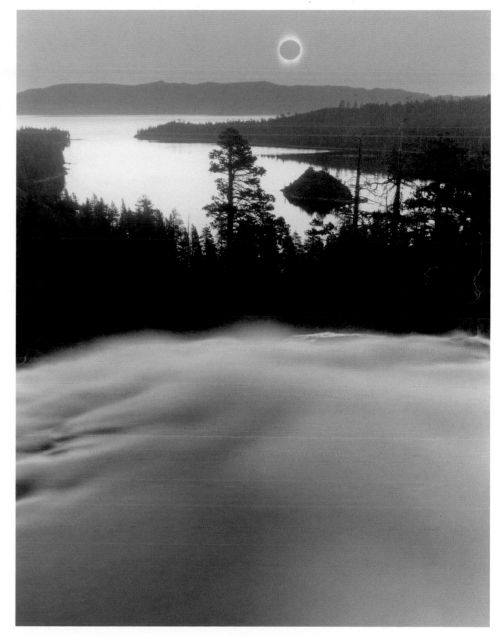

Five:
In Practice

\#

Landscape. Wildlife. Portraits. Abstracts

THEORIES ARE PROPOSED EXPLANATIONS, A SERIES of ideas that may or may not work in reality. The actual practice of composition will require flexibility in thought and approach, but it is a philosophy that is open to anyone. There are many philosophical approaches to photography, just as there are myriad compositional styles, and good results are available to any photographer.

Landscape

In the traditional sense, landscape is a classical genre of photography, and offers many variations in compositional approach. The grand landscape has been a touchstone since the advent of photography and still resonates with modern aficionados. This school of thought often involves using dramatic skies, generally filled with either white, towering cumulus, or else covered by ominous, lowering storm clouds. A sweeping foreground will lead into a middle section, usually a strong graphic design. A still lake reflecting a series of jagged peaks is one familiar example of this style, although it can just as easily be a large expanse of grasses leading into the distant horizon.

Variations on this classical theme abound, but the underlying common thread is a strong reverence for the grand vista of nature. Mid-range views also fit into this school of thought, and the same basic formula will usually be applied. Using some compositional element to bring the photographic horizon closer, the range is foreshortened, but still presents a large slice of the landscape. A row of dense trees might close off the distant view, but with some fore and middle-ground, the image will still be considered a traditional landscape view.

Unusual accents may be used to inject interest into a landscape scene, and this can be anything from odd weather to fire. These oddities will often improve a photograph, adding a strong compositional element.

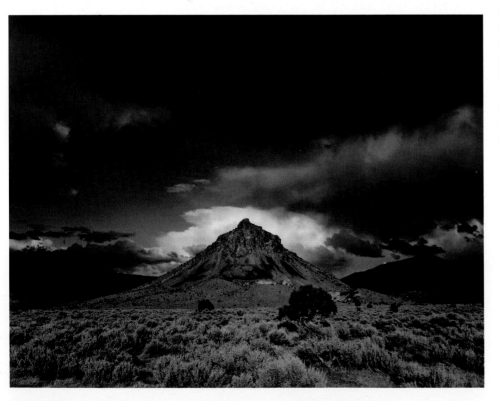

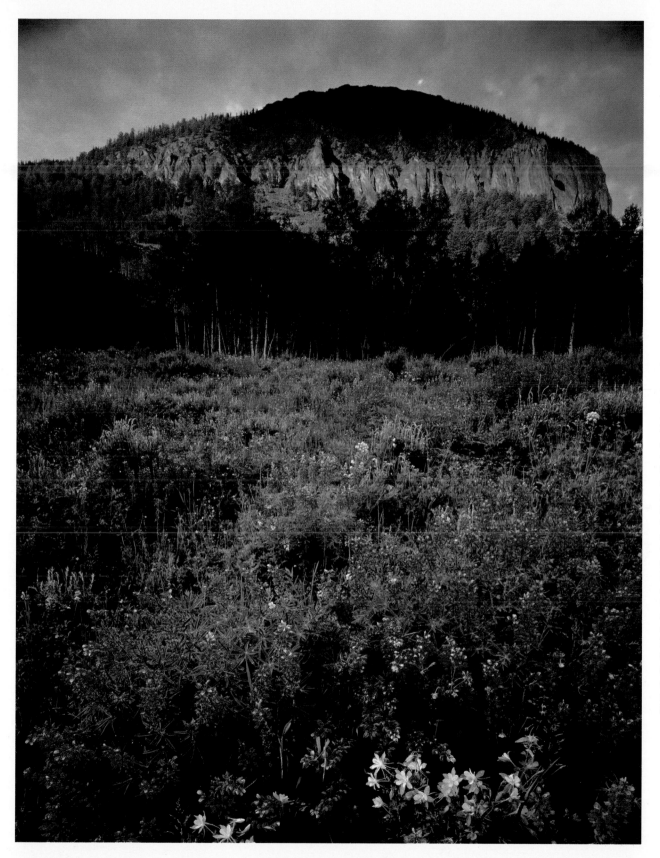

Blue Columbine, Mount Crested Butte, Colorado
Dramatic light will always enhance a traditional landscape photograph, and there is none as exciting as storm illumination. Finding this clump of wildflowers, I placed them at the bottom of this composition, using the butte as the background. A storm had been swirling around all afternoon, but at sunset the clouds opened, letting a few minutes of dramatic light hit the butte. This is a classic use of near–far technique.

OPPOSITE
Round Mountain, Utah
Dramatic weather patterns are beneficial when applied to black and white landscape, and a severe storm near my hometown of Moab swirled over a small peak, giving a rare photo opportunity. Round Mountain is a volcanic cap, the remains of a prehistoric eruption, and is perfectly proportioned. Standing in a downpour, using my poncho to protect the 4 × 5, I was wet and disheartened. The storm was violent and there was no sign of any photo possibilities. Near sunset, a small white cloud drifted behind the moutain and the sun simultaneously peeked out from under the storm. There was only time for one exposure before the light blinked out and the rain began with renewed ferocity. The one sheet was good and Round Mountain is one of my better traditional landscape images.

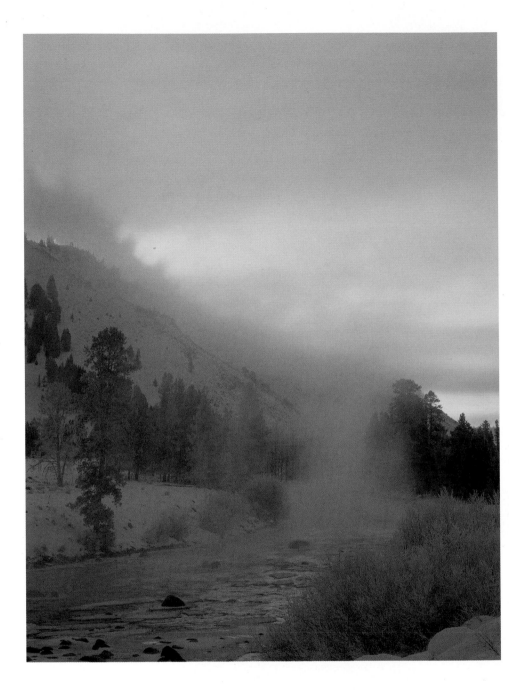

Salmon River, Idaho
When unusual weather is combined with a landscape,
a degree of interest is usually added to the photograph.
A pre-dawn lifting fog over the icy Salmon River in Idaho
combined with mist rising from the water to create a pastel
image. The sunbeams shooting through the fog add some
linear tension, helping to complete this composition.

Wind Canyon, Theodore Roosevelt National Park, North Dakota
Hiking to this viewpoint in Theodore Roosevelt National Park,
my attention was caught by the perfect bend in the river.
The buttress jutting in from the left side of the scene completed
this composition, and a short wait past sunset provided a soft
and lovely illumination. This photo contains many aspects of the
traditional landscape, including a dramatic sky reflected in water.

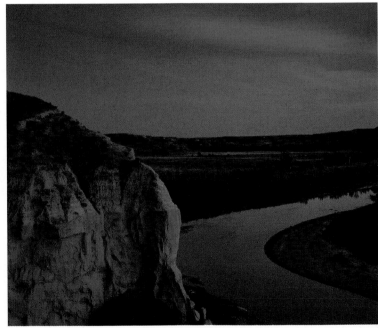

Pueblo Bonito, Chaco Culture National Historic Park, New Mexico
Several years ago, I was working on a calendar of the Four Corners region, that area in the U.S where Colorado, Utah, New Mexico and Arizona share a common border. Chaco Canyon contains some of the most dramatic prehistoric ruins in the southwest, and I had visited this park many times on the ground. Wanting a different take on the main ruin, I decided to photograph Pueblo Bonito from the air. This is a huge and intriguing site, and its shape is unusual. The morning light was excellent, and this was the best image from this flight.

Alternative Approaches

There are other methodologies that can be applied to nature photography, and one main alternative is the use of symbolism and abstraction. By approaching a natural subject with the intent to translate it through invention, either by using some degree of abstraction or by altering scale, the photographer begins to add interpretation, to insert more personal philosophy into an image. Abstraction must be used carefully, because when an image crosses into the totally abstract, it will usually cease to have any meaning or attraction to most viewers. By skirting along the line between realism and abstraction, giving some clues as to the subject without revealing its full nature, a powerful and intriguing composition is possible.

Opportunities for semi-abstraction abound in the natural world, especially in close-ups. Choosing small slices of nature, closing in on interesting patterns and designs, this technique introduces a freedom of expression, transcending the rather stylized traditional approach to the natural world.

Even within abstractions and close-ups, the various compositional approaches will retain some validity. The rule of thirds, for example, will work well, even when applied to near compositions and abstractions. Near–far techniques can also apply, only the distance between the various elements is far more finite than with the usual application. Shapes become very important, often dominating the image framework.

Sandstone Striation, Utah
The natural world is rife with abstract subject matter and this is particularly true in the red rock country of southern Utah. These odd extrusions were popping out of the sandstone, and the colour and light blended together to make a nice abstract.

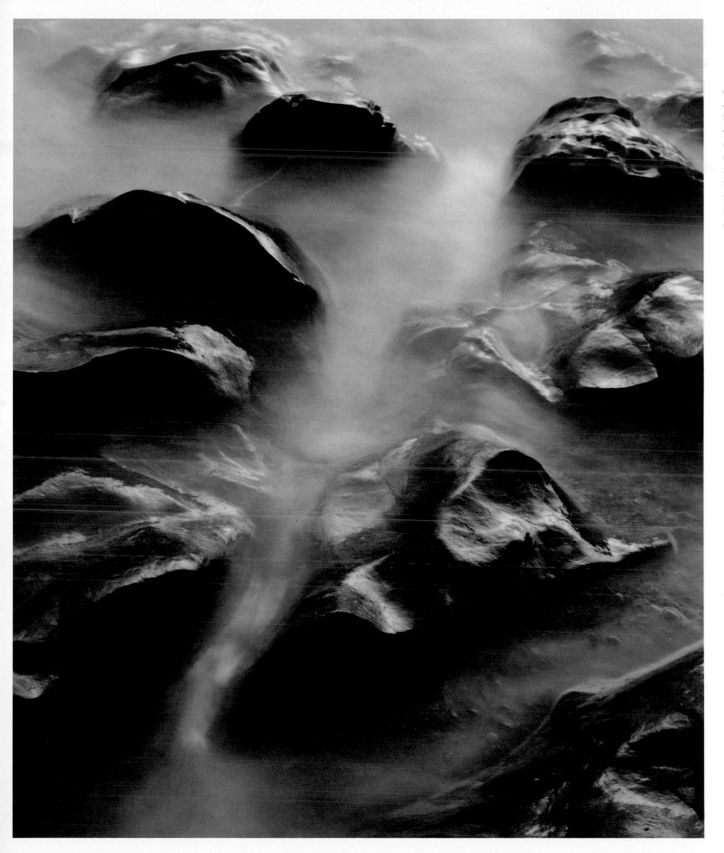

Second Beach, Washington
Any rushing water can work well in a photograph, especially when overlaid on solid shapes. This is a small, sculpted group of rocks on a Washington beach, and the rising tide was rushing through them. The setting sun gave a rich illumination to the central stretch of water, and this is accented by a long exposure.

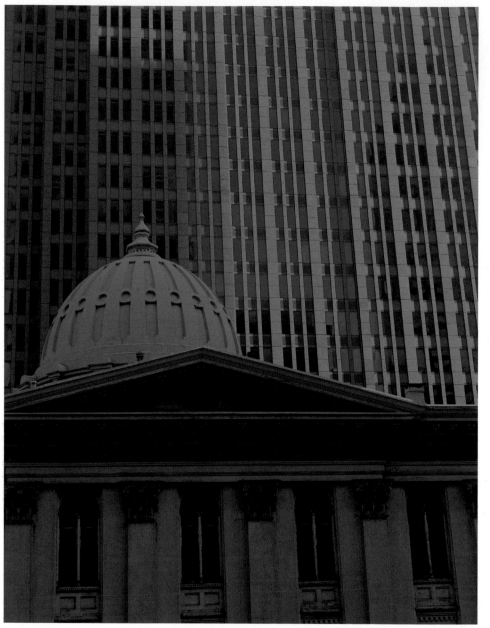

Urban and Architectural

Photographing man-made scenes introduces severe planes and right angles, considerations that must be taken into account when deciding on one's compositional approach. Tall buildings create deep canyons of glass and steel, blocking light and introducing both extreme and flat contrast. Glass surfaces become huge mirrors, reflecting light, changing illumination source angles to a confusing degree. All of these factors, however, may be used to advantage and can create some fantastic compositions.

The mirroring aspect that is introduced by huge, multiple panes of glass offers great possibilities to a discerning eye. Using a new building facade to reflect an older style of architecture is one technique that might be used, and using a bank of glass to bounce light, illuminating an opposite subject, is another possibility.

Urban decay exists, to some degree, in every city in the world. This blight is generally considered unattractive, but through the use of judicious cropping, it may allow for some interesting photos. Details of abandoned building interiors, worn doorways and alcoves and broken windows all offer possibilities to the open-minded photographer. There have been many photo books published on various aspects of urban and suburban decay and some have been very well done.

St. David's Welsh Chapel, Philadelphia, Pennsylvania
Contrasting different architectural styles against each other is a valid compositional technique and will be especially effective when modern and old buildings are combined in one image. This chapel sits adjacent to a new office building in Philadelphia, and the juxtaposition created an interesting photo opportunity.

Oak Alley Plantation, Louisiana
The outlying areas surrounding urban centres often contain interesting subject matter, sometimes of a historical nature. This antebellum mansion near New Orleans is surrounded by old and majestic oak trees, with one double row forming a tunnel that shades the path to the house. By minimizing the size of the mansion and exaggerating the overhanging trees, this has become a study of a man-made object residing in nature.

Swann Memorial Fountain, Logan Circle, Philadelphia, Pennsylvania
Water is omnipresent in cities, as a river running through the urban centre or in fountains. There are lots of photo opportunities to be found in these instances, and fountains are always interesting. Swann Memorial Fountain is in downtown Philadelphia, and it contains some unusual statues. A long exposure (three seconds) blurred the water, and the turquoise blue of the pool is lovely.

Ukrainian Catholic Church
Trying to find a different angle on Pittsburgh, I was exploring the edges and found an attractive gold-domed church. A light fog wreathed the distant buildings as the sunrise lit up the dome, giving an unusual take on the city.

Photographing City Skylines

Cities are an interesting subject and may be approached from many different viewpoints. Skylines can be a rewarding angle, and using a foreground body of water will enhance this compositional style.

Many cities are situated on a harbour and this can be used to good effect. Shooting away from the rising or setting sun, there will always be interesting reflections coming off buildings.

Civic Center, Pittsburgh,
Pennsylvania
Another technique that will liven
up city skylines is to include an
odd design or shape, contrasting
this against the traditional
skyscrapers associated with
cities. On a recent rip to
Pittsburgh, I employed this style
in a downtown photo, using the
dome of the Civic Center as a
foreground to the tall buildings
behind it. Three trees gave a
nice base to the composition
and tight cropping combined
with the dawn sunlight serve to
complete the scene.

Aerial Techniques

Aerial work has a different set of techniques and requirements and is a very interesting style of photography. Small planes and pilots can be hired, as a rule, for a reasonable amount of money (the average in the U.S. is around $75 per hour for a small Cessna and a professional pilot), and the key is to time your flight to coincide with the best angle of light for the subject, staying in the air for as brief a time as possible. As a rule, morning and evening are best, as sidelighting will highlight the folds and forms of the landscape.

The camera should be an SLR, either 35mm or medium-format. All of my aerial work is done with a normal lens, and I have the pilot put the right distance between the camera and subject. As the exposures are made at high speed, I often crop out extraneous elements during printing. A good pilot will be able to follow your directions, and also be able to slow his plane to just above a stall, allowing time to compose a shot. The shutter speed needs to be either a 1/1000 or 1/500sec, as the speed of the plane will cause blurring in the negative at any slower speeds. The focus will always be set on infinity, and the lens can be set on the largest aperture. When the focal plane is on infinity, depth of field ceases to be a problem, as everything within the scene is at infinity.

A high-wing plane should be used, otherwise the wing will intrude into every shot. Cessnas are fine planes for photography, and are ubiquitous around the world. The window should be lifted during the exposures, as the plastic will affect focus. Again, Cessna windows generally lift up, and the slipstream holds them out of the way during exposures. Low and slow is the aerial mantra, and a good pilot will be able to accommodate this need.

My favourite film is Ilford HP-5 Plus in 120 format, as it gives a nice, smooth tonal range when developed in Kodak HC-110. Through bitter experience I have learned that, no matter how sharp the contrast of a scene might be, a one-zone push is always required in the film development. The reason for this continues to elude me, as it goes against common sense. This will apparently remain one of those 'just because' aspects of photography.

My aerial camera is a Pentax 67, a sturdy workhorse with the added benefit of having an aperture of f/2.8, and a shutter speed dial up to 1/1000sec. The in-camera meter gives a decent averaging reading, which is all you can do for aerial work. The speed and conditions make it virtually impossible to take any detailed meter readings. This camera is an SLR, and is fairly easy to handle under rough conditions, such as when the plane hits a pocket of dead air and the camera becomes intimate with your nose.

An added bonus to flying is that it allows you to scout for ground shots, giving a nice overview of the lie of the land. There have been several times when I noticed a promising area from the air, returning to it later on foot with my 4 × 5.

San Rafael Swell,
Emery County, Utah

Tallgrass Prairie National Preserve, Chase County, Kansas

Alligator, Everglades National Park, Florida
Using an animal as an accent to its environment is a useful wildlife technique. This alligator was sleeping on the bank of a slough, deep in the shade, while the setting sun lit up the background vegetation. The graduated hues of the water are lush and I consider this to be my best wildlife photo.

Wildlife

Wildlife photography is a fine art unto itself, requiring an almost inhuman patience as well as an intimate knowledge of the particular species being stalked. As a rule, only perseverance will result in decent wildlife photos, and most spur-of-the-moment shots will be poor.

The general guidelines of composition also apply to this school of photography; for instance, the rule of thirds will be effective in illustrating an animal's environment. If the subject is placed in the left third of a horizontal scene, and is facing into the rest of the composition, a strong sense of the surroundings is introduced. Motion also may be applied to wildlife work and can be an indicator of speed. There have been several powerful images of running cheetas using the panning technique, and a strong feel of speed always emanates from these photos.

Close-ups, when possible, are an invaluable technique with wildlife. Zooming in on an animal's eye will give an intriguing portrait, and details of fur or claws can approach the abstract.

As with other fields of photography, light is a vital part of wildlife work. Flat light will sometimes work with wildlife, and low, angled light is always rich and will enhance whatever image it is used for. Harsh midday light can also be applied to some animal photography, but needs to be used with care. Hard, black shadows generally detract and should be minimized. Showing a large segment of the animal's environment and making the subject a small element within the scene is a viable technique. Using the main subject almost as an accent is a subtle technique, but with the right scene and light it can result in a powerful image.

Horses
Panoramics don't usually work well in wildlife photography, but if there is a strong compositional balance this format will occasionally work. These two horses had come up to me, probably looking for treats, while the rest of the herd stayed back from the fence. The far horses offer a counterpoint to the near, giving depth to this composition.

Grey Whale, Magdalena Bay, Mexico
Whale photography is quite frustrating, requiring an almost telepathic ability to predict when and where they will appear. Spending several weeks on one of the main grey whale bays in Baja, I managed a few decent photos of these amazing mammals. Magdalena Bay is narrow and calm, both factors that aid in whale photography. This grey popped up close to our boat, performing an angled spy-hop, a technique they use to look around above the water's surface. This was a reflexive grab shot, and I placed the whale dead-centre in the composition.

Grey Whale Fluke, Magdalena Bay, Mexico
For some unknown reason, whales will occasionally lift their flukes out of the water, a very hard happenstance to catch on film. This male grey whale swam under our boat, and when he surfaced on the opposite side, raised his tail two metres out of the water. The water sluicing off his fluke adds a nice accent to the photo.

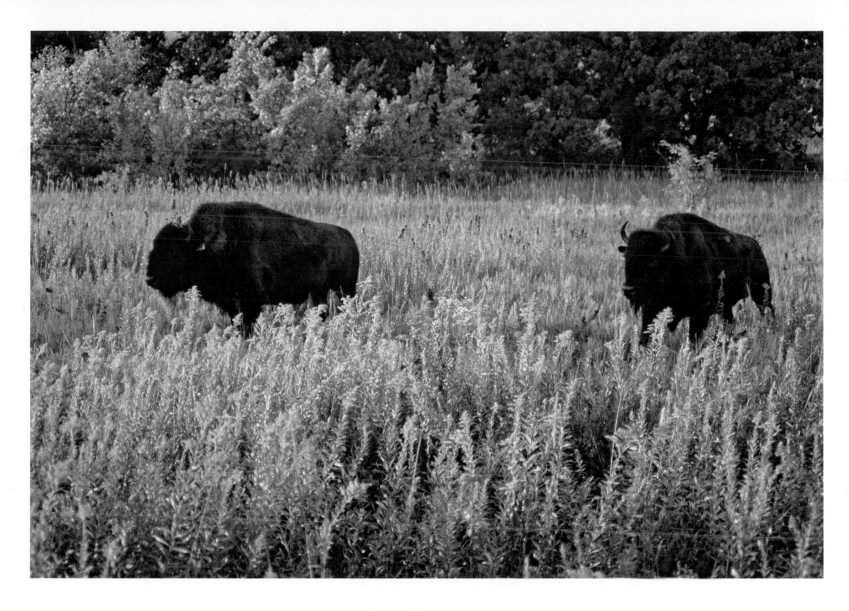

Buffalo and Goldenrod, Konza Prairie, Kansas
Backlighting is difficult to use well, requiring an interesting
element to make it work. In this case these two bison were
walking through a field of goldenrod, and the lighting made
the flowers glow.

Jan
Head-on portraits, with strong eye contact, will sometimes work well. This subject has an enigmatic expression, which adds some mystery to the photo, and the pattern of her dress adds compositional interest.

Portraits

There are many methods to portray people, ranging from the elaborate studio set-up, with multiple lights and fancy backdrops, to the totally candid grab shot, where the subject often doesn't realize they are being photographed. The common thread running through all these approaches is composition, the careful arrangement of face, body and surrounding shapes.

Angles and expressions play a large role in portraiture and are equally as important as light. Having someone stare straight into the camera, though a hard technique to pull off, will sometimes add mystery to a photo. Conversely, having the person look away, tipping their head either up or down, has the potential to add intrigue. The variations in distance, expression, amount of torso included and background are myriad, offering the photographer many options.

STUDIO PORTRAITURE

There is a complete school of thought around just this style, and studio lights are complicated and cumbersome. The basic compositional rules still apply, and some arrangement should be used to increase interest. Props are a good method and are often used. Having someone rest their arms on something will add some balance or tension, as will unusual angles. Clothing styles will also play an important part in portraiture.

ENVIRONMENTAL PORTRAITURE

Photographing people in surroundings that they have some connection with can greatly enhance a portrait. Shooting a person with their horse, for example, gives information about their interests, and allows for compositional creativity. Another example would be taking a portrait of an artist with some of their work behind them, a technique that has been used successfully many times.

Environmental portraiture adds extra information about the person being photographed, telling a story about the subject.

CANDID PORTRAITURE

Candid portraits are hard to do well, but can occasionally catch the true person on film. Following people as they engage in some activity is a good method, but remaining unobtrusive is the key. This type of portraiture will often capture the essence of a subject, as we all reveal ourselves in unguarded moments.

LIGHT AND PORTRAITS

As with all photography, light is paramount. Using interesting light will vastly improve any portrait, be it artificial or natural illumination. Soft light will erase blemishes, while hard-edged illumination will accentuate lines and faults. The light employed will completely depend on the result desired. Sidelighting will throw odd and interesting shadows across the person's face, while soft light will soften down an expression, and make for a mellow portrait.

Karen
Having a subject look away will often add allure to a portrait, as will interesting backgrounds. Here, the combination of the hat, the angle and the old tank come together to make this a decent portrait.

Still Life

Still life photography offers a quiet grace and has been in vogue during recent years, particularly images of plants. There are several advantages to this style, chief among them the absolute control over light that is available. Another plus is the freedom of design, as the subject may be shifted to suit the photographer's whim.

There is a plethora of dynamic compositions available to the still life photographer, but some basic rules still apply. In this type of photo, tension becomes very important, and maintaining some balance between the shapes and elements is paramount. Blank space may be used very creatively in still life, but it must be counterbalanced by some implied movement, such as a curving plant stem arcing over the empty area.

Still life covers a wide gamut, but the common threads are that the subject has been arranged and the light controlled. The subject can be anything, and the location can be anywhere.

Barnacles and Dolphin Skull
This still life was taken on my back porch using available light with fill-in flash. It shows a large barnacle cluster that my wife found years ago, and a dolphin skull my brother-in-law picked up while beachcombing. The arrangement has introduced an odd balance between the two, and the wrinkled sheet – which annoyed me during the shoot – actually accentuates the objects.

Cliches and New Angles

There are certain scenes that have been photographed ad nauseam, to the point where originality becomes virtually impossible. However, there are always new ways to photograph these scenes and these angles will depend on a number of factors. Finding a new view of a tired subject can be hard but, with imagination, it is possible. Unique weather happenings always open new possibilities on time-worn scenes, as do unusual lighting conditions.

Duck on a Rock, Grand Canyon National Park, Arizona
The Grand Canyon is fantastic, one of the world's wonders. It is also notoriously difficult to photograph with any originality, requiring patience and imagination. As a winter storm was clearing, with a heavy fog settled down in the main gorge, I walked out to Duck on a Rock, a large boulder balanced precipitously over the canyon rim. The sun was behind a thick cloud, muting the light, and this worked well with the receding fog. These unusual weather conditions gave me one of my better and more original Grand Canyon photos.

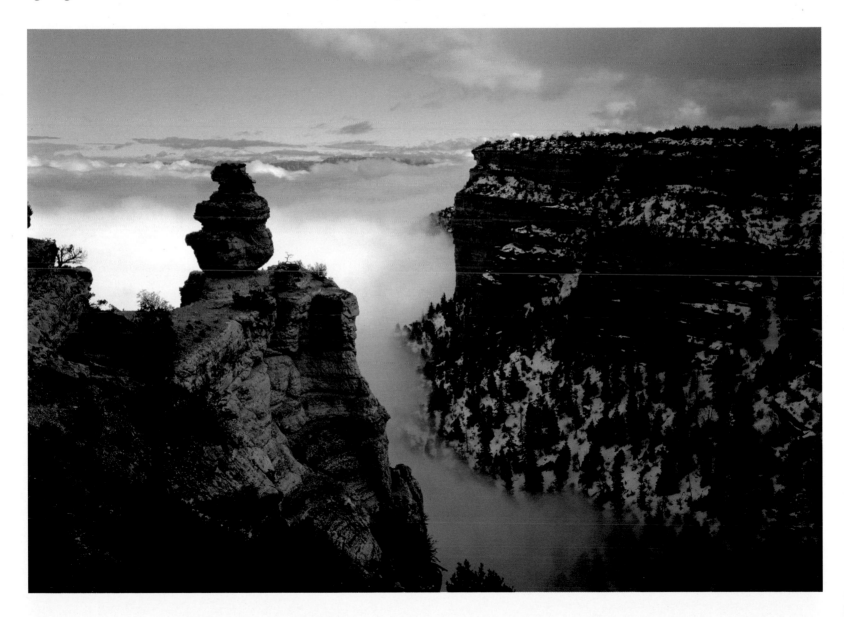

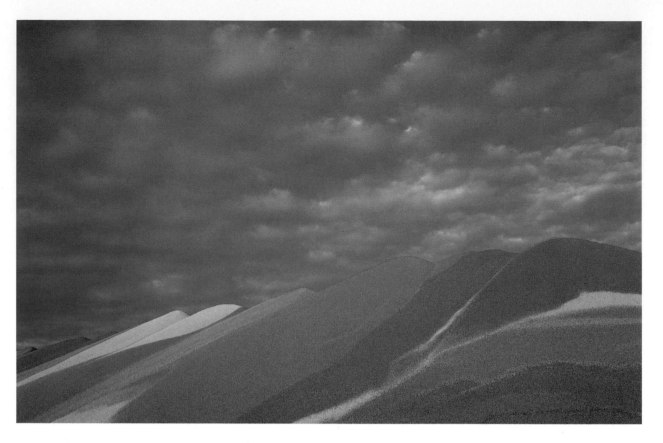

Milo, Kansas
Over the years, I have accepted the occasional assignment, usually because the subject matter held interest for me. A magazine wanted photos of Kansas agriculture (just the type of open-ended assignment I like), and they gave a generous deadline. During one trip, I found these huge mounds of milo, which is a grain grown for domestic animal feed. It is a very photogenic crop, and the cloudy sky added to this composition.

Photojournalism

Reportage photography, which is also known as photojournalism, requires quick reflexes and a mobile camera. The 35mm has been the mainstay for this style ever since the format was adopted, and it remains the standard.

This is the ultimate grab-shot photography and the successful image will tell a story, sometimes in a plain and clear manner, other times with a certain degree of mystery. Composing these scenes is tricky, as events are usually unfolding at a rapid and unpredictable pace. Good photojournalists develop an uncanny ability to predict how an event will unfold, and hone their reflexes to be able to catch the happenstance on film. A near–far composition is often used, with one person looming close to the camera on one side, while other people engage the rest of the frame at more of a distance. Angles become very important, and a low view will exaggerate movement and shapes, accenting whatever is unfolding in the scene. As with any composition, maintaining tension and interest between the various elements is important, and this particularly applies to this style of photography.

Reportage tells a story, sometimes an obvious one, occasionally one less clear. Photojournalists have caused huge change in the world, as people are often moved more by images than words, and a series of horrific photos will grab and hold the viewer's attention. This type of photography requires amazing commitment and photojournalism often entails great danger.

Fire in the Landscape
The tallgrass prairie once blanketed the central United States and appeared to the early settlers as an 'inland ocean'. The prairie only exists in remnants, as the soil was rich for farming. Sections were spared, usually because of accessibility problems, or because there were too many rocks for the plough to till the soil. These sections of tallgrass have become a favourite subject of mine, and I am always looking for new ways to photograph the grasses. Every spring the prairie is burned, facilitating rapid and clean regrowth. This is a recreation of natural events, and is one of the most spectacular things I have ever witnessed. Over the years, I have shot many burnings, always looking for new ways and angles. During the day, the fires are often large enough to mute the sun, giving a strange and alien feel to the landscape. Gauging the wind becomes a useful skill, and my first prairie fire shoot ended with melted tips on my tripod legs.

Abstracts and Close-Ups

Photography lends itself to abstraction, but it must be approached with care. When an image crosses over into total abstraction, when all clues to the original subject matter have been removed from the composition, the photo often becomes uninteresting, and holds meaning only for the photographer. By inserting small hints as to what the subject is, leaving the occasional clue within the image, the viewer will be drawn into the scene.

The potential for abstract work is everywhere, both in the natural world and in man-made objects. Nature is often abstract, offering patterns and shapes that, when the surrounding environment is cropped away, become enigmas. Details always have possibility, and peeling paint has been a popular photographic subject for many decades. Broken glass, old facades and industrial clutter all have abstract potential.

Close-ups are a major technique in abstractionism, but they can also be quite straightforward. Details of plants – where there is no attempt to shroud the subject matter – will often be interesting. Rocks also hold strong close-up potential, especially ones with unusual patterns and shapes.

There are many approaches to photography, each with a strong validity. No matter the style chosen, a careful attention to both light and compositional technique will reward the photographer, as will a commitment to quality.

Banana Leaf, Guadeloupe
During a short visit to the Caribbean island of Guadeloupe, I hiked up a slippery trail to explore a viewpoint. During my walk this pair of banana leaves at the side of the trail caught my attention. Desperately wanting a break anyway, I slithered over to the leaves and composed this photo with my view camera. The green and yellow mottling of the larger plant combined with the brown leaf and diffuse light to give an interesting close-up. It was fortuitous, as, upon my eventual arrival, the viewpoint was clouded in, offering no photo opportunities.

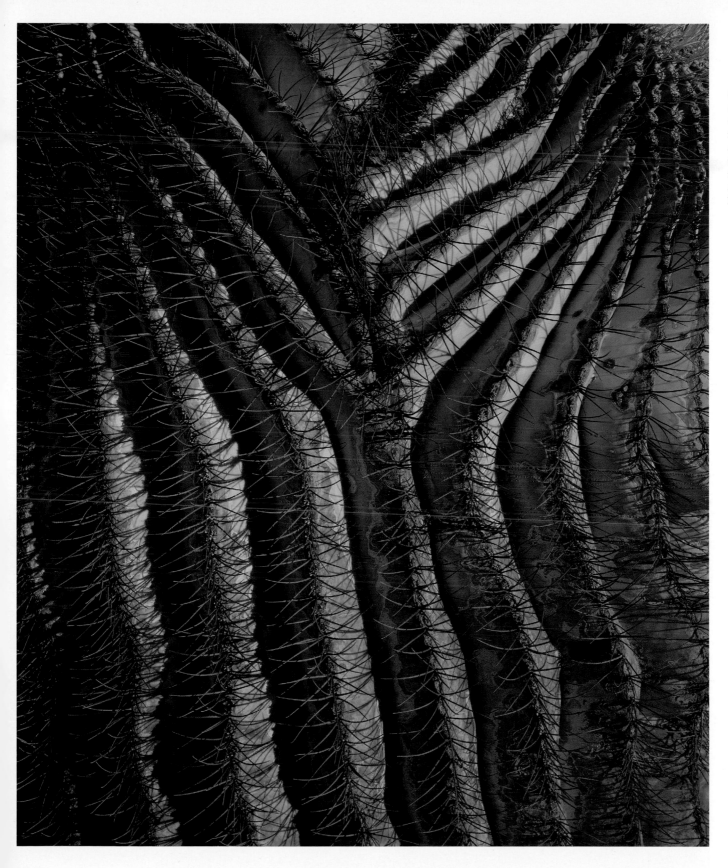

Giant Barrel Cactus, Santa Catalina Island, Mexico
Close-ups of the patterns found in plants can be very rewarding, and often fairly abstract. While the subject matter of this image is obviously a cactus, the ridges are strange, requiring a second look from the viewer.

**Six:
On Computer**

Perspective. Corrections. Converting. Masks.

IN PHOTOGRAPHIC TERMS, COMPOSITION IS A constant, similar to a square root number in mathematics. The arrangement of the multiple elements within any scene will depend on the shape of the format chosen, and the platform chosen for exposure won't have very much influence on compositional decisions. The art of composition transcends the medium used, relying instead on an intuitive sense of pattern, design and colour. That said, there are variations of approach and alteration that can be applied through digital work, and this chapter will explore these possibilities.

Employing a digital platform offers several alternatives to traditional photography, chief among them being the ability to add or remove elements and alter existing ones. With practice, image processing applications such as Photoshop allow the photographer to remove small, intrusive objects from a photograph. Small signs, a distant building or jet contrails may be excised from an image, and with experience there will be little evidence of this manipulation. When larger changes are attempted, however, it becomes more difficult to hide the alterations.

The rule of thumb for any manipulation applied within an image, both during and post-exposure, is that there should be no evidence of the alterations. The only exception to this is, of course, when the manipulation is overt, and meant to be noticed. Outside of this circumstance, great care must be exercised to blend edges. Digital manipulation is an option that should be used to enhance photographs. A strong and distinctive image is always the end goal in photography, and with Photoshop, imagination is only limited by experience. Tweaking a photo simply for the sake of manipulation should be avoided, as any technique or tool available in photography should be used to further the image, to strengthen the compositional possibilities inherent in any scene.

COMPARE SHOTS

The glacial age of North America pushed massive ice walls deep into the continent, reaching as far south as central Kansas. As the glaciers retreated, they dropped rocks and boulders, leaving a trail as mute evidence of their withdrawal. These reminders tend to be fairly mundane rocks, but on a remote hillside in Kansas there are some unusual glacial erratics. I was pleased to find these red quartzite boulders, rounded and polished by their grinding journey in the ice. Placing a large rock in the foreground, I set up a near–far composition, trying to show the extent of the boulder field, and making use of the lowering horizon clouds.

The film was flat, displaying none of the vibrancy I saw while shooting. My excitement over the scene must have hidden the fact that the light was lifeless, sucking the contrast out of the image.

After scanning, we began pushing the contrast of the lower two-thirds of the photo and lightened the foreground rock until it began to glow. The corrected version matches what I saw in my imagination, and this was a case of Photoshop rescue.

Going digital
Computers offer a chance to be creative after the image has been photographed.

Glacial Erratics, Kansas
Version one

Version two

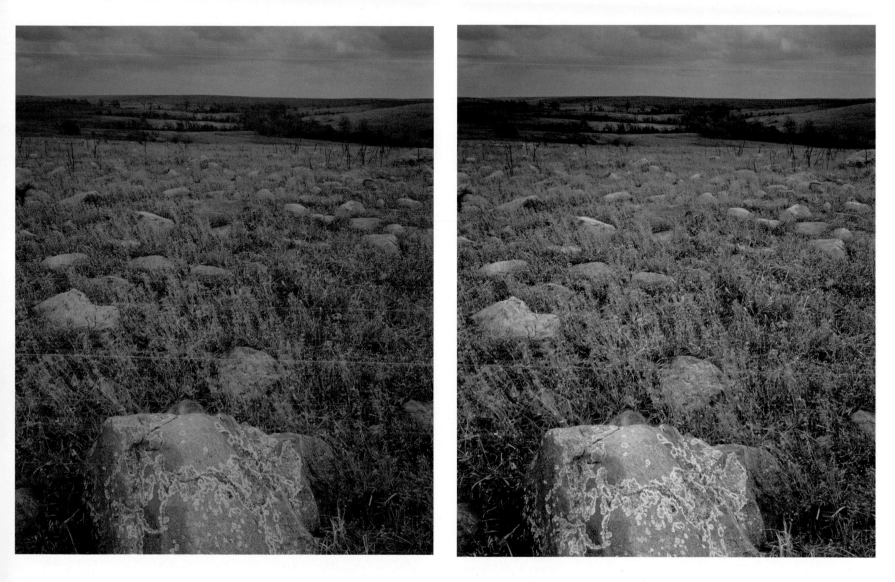

*Juniper in Fog, Badlands
National Park, South Dakota*
Version one

Version two

Perspective

Digital offers interesting perspective controls, including some that are unavailable in a traditional approach. When Photoshop is used for this purpose, the control must be anticipated pre-exposure, and this previsualization will greatly aid all post-exposure work.

By shifting focus through an exposure series of the same scene, and then stitching the multiple images together after the fact, a great depth of field may be achieved. A foreground object can be enhanced, causing a looming effect, strengthening what was a weak element.

Breaking a scene into multiple quadrants (stitching them together post-exposure) will avoid perspective distortion, particularly when wide-angle lenses are used. This stitching technique may be employed to create panoramics and will also control perspective, avoiding the wrap-around distortion common to many panoramic compositions.

Software is available that will automatically stitch different images, or it may be used to blend overlays of the same scene, a good method to control both focus and contrast. By making different exposures of the same scene, then selecting the correctly exposed areas from each image, an amazing degree of contrast control is available. Mixing a properly exposed sky with a separate, good exposure of the foreground provides a strong compositional tool for the photographer. This technique will work with a series of different exposures, allowing infinite contrast control for any given scene.

Badlands National Park in South Dakota has several small outlying sections, each with a different topography from the main unit. Camping at one of these, I was surprised to wake up in a heavy fog, a rare happenstance in this area. The sun was lighting up some distant foggy ridges, leaving the foreground badlands in deep, blue shade. This scene was changing quickly, necessitating some rapid camera work.

When I received the film from the lab, it was dark and flat, noticeably underexposed. There was none of the drama happening in the transparency that I saw on the ground glass of the 4 × 5.

Scanning the film, we began to play with Photoshop, trying to recreate the scene as I remembered it. After some overall lightening, the upper strip of sunlit ridges was brightened even more, increasing the contrast of this area of the image. The final, adjusted photo was good, and looked exactly as I remembered the original scene.

Using Photoshop to correct exposure mistakes

Landscape photography can present difficulties, particularly when weather events are changing rapidly, or during temperature extremes. When circumstances are moving at a bewildering rate, correctly figuring exposures becomes exponentially harder. Positive film (colour transparency film) also has a notoriously narrow window for a proper exposure, a feature that exacerbates this problem. Poorly exposed film, however, may be saved through the creative use of Photoshop.

After an extreme freeze, I was walking alongside one of my favourite canyon creeks and found these ice bells. Splashing water from the rapid creek had coated these low-hanging grasses, forming these esoteric shapes. Dropping the tripod as low as possible, the camera was delicately poised over the freezing water. This canyon is steep and narrow, staying in deep shade throughout the winter, and it was very cold sitting by the stream. Perhaps I experienced a mild brain freeze, because when the film was returned from the lab it was underexposed by one and a half f-stops.

Scanning the film, my digital expert Chris Conrad then began lightening the photo. This scene didn't require very much work in Photoshop, as the adjusted image was good, with rich saturation and a strong contrast balance.

Ice Bells, Utah
Version one

Version two

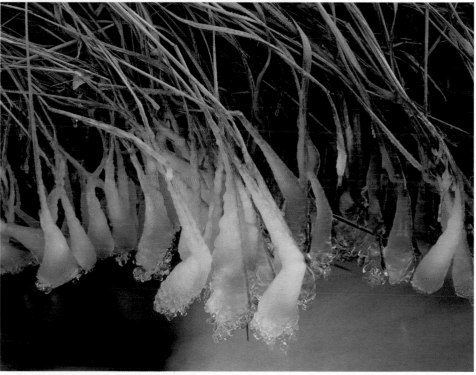

Zone System
A methodical way of calculating film exposure to ensure that shadows, highlights and midtones appear as desired by the photographer.

Converting to Black and White

The best approach for creating a fine black and white print remains the traditional one, as a negative offers more controls and finer quality than the currently available digital techniques. Through the Zone System method, exposing for the shadows and using development to determine highlight densities, an exact control is available. The quality of digital crossover, however, is slowly and steadily improving and it has become a viable option.

The method that will give the best results when digitally crossing from colour to monochrome is to employ the channels available through Photoshop. Using the red, green and blue channels allows the photographer to mix the various levels and gives better tonal scale control than other options. This method is akin to shooting black and white film with colour filters, with further control, allowing the application of different colour channels to select areas within the scene.

One important technique is the application of layer masks. Using this option allows the alteration of different areas within the image, and by tweaking the contrast in certain areas through colour channel changes a good tonal control is available. Altering the red level within a blue sky will control the tones, either lightening them or bringing them down, while altering the foreground levels will shift contrast and tonal range within this area.

Digital papers handle monochromatic images well, particularly the matte-finish ones. These papers give a rich depth to the final print, somewhat similar to a platinum print. There are several printing programs available, but the rule is to apply as many different tones of black and grey as possible.

Digital is rapidly becoming the photographic method of choice, in large part because of the seductive ease it offers to photographers. By high-grading the aspects of this approach, choosing those parts that work well, and then blending these with certain aspects of traditional photography, some amazing results may be achieved. Careful selection (as with so many things in life) is the key, and the general obfuscation offered by product manufacturers must be ignored as much as possible.

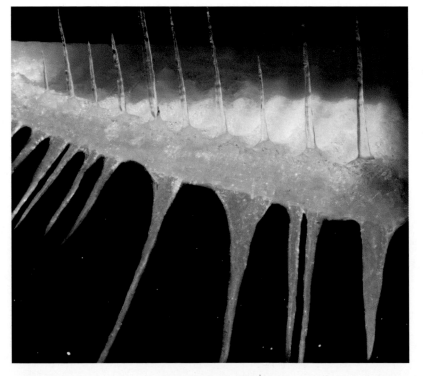

Roof Icicles at Night, Moab, Utah
During the unusually bitter winter of 2007–8, Moab was locked in a long cycle of freezing weather. A series of brief thaws created some intriguing icicles on the edge of our roof and I shot this composition. After the first printing session the ice looked fine but the background – a large tree in our front yard – was very distracting. After some thought, I used bleach to remove the background from the negative, a technique new to my experience. After the second printing attempt, the image was improved, but was still lacking a finishing touch. Having my friend Chris Conrad create a digital negative of a starry sky, I overlaid it on the icicle negative and printed this combination. This was an odd series of transitions but the final photograph seems to work.

COMPARE SHOTS

When first starting aerial photography I bought a Pentax 67 and would switch from colour to black and white film as the occasion demanded. On a flight south of Moab, Six-Shooter Peak was throwing a fantastic shadow and some clouds behind us were forming a shadow halo around the spire's jutting shadow. This was one of the finest aerial scenes I had witnessed to date, and held huge potential. There was colour transparency film in the camera and, after snapping a few exposures, I quickly replaced it with black and white while the pilot flew a holding pattern.

Advancing the film and cocking the shutter, I pointed the camera through the open window, ready to catch the scene in monochrome. To my chagrin, the horizon clouds had rapidly expanded, completely blocking the last rays of the setting sun. Convinced this would have made a fine black and white print, I was very disappointed to have missed it.

Years later, while scanning the Six-Shooter transparency to fill some colour print orders, I decided to cross it over and find out how it looked as a monochromatic image. Adjusting the three colour channels during the crossover, we pushed the red channel, letting the other channels fall away. Because the dominant colour of this image is red, this lightened most of the scene, particularly the highlight on the spire. It also had the effect of opening the shadows, giving them strong detail.

No matter how much this image was tweaked in Photoshop, the final print, while decent, could never match the equivalent in a silver print made from a good black and white negative. This experience convinced me to buy a second Pentax, so I always have a camera with black and white film for circumstances like this one.

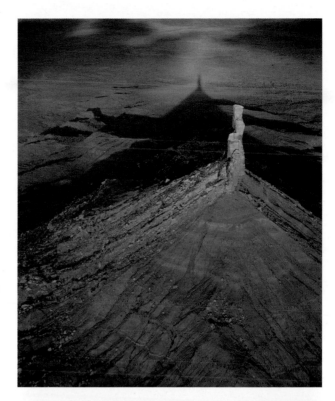

Six-Shooter Peak
Version one

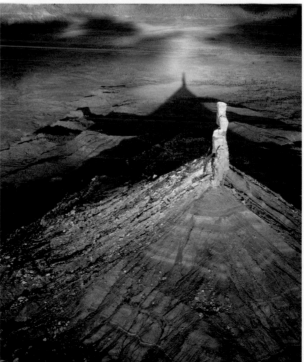

Version two

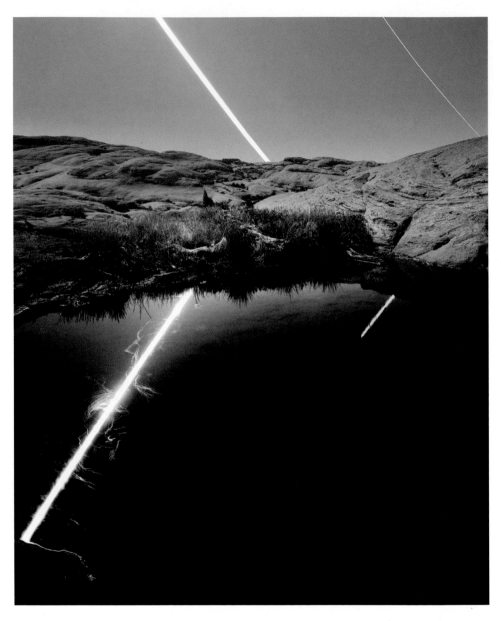

Moonset Reflection by Chris Conrad

Mixing traditional and modern

My friend Chris Conrad has perfected an interesting workflow, masterfully blending traditional and digital techniques, and through this technique he has produced a strong portfolio. Shooting black and white negative film with his 4 × 5, making use of the myriad movements offered by this camera, he decides exposure based on shadow densities, and then uses different development times to control highlight densities. After this completely traditional beginning, he scans the negative at high resolution, and crosses over into digital printing. This mix of approaches is working well for him and has resulted in a body of original, high quality work.

Chris writes: As a photographer in the American Southwest, I have been seeking new interpretations of a landscape that has been photographed by myriad masters over the last century. My early quests resulted in a collection called *Oases* which represented ephemeral water in the arid desert through images of snow, ice and transient pools. Reflections became my favourite genre and I spent countless hours studying pools, watching for rain and leaping into action when the conditions were right for a composition of a particular reflection. I was able to hone many technical skills through the difficult tasks of exposing and printing these reflective images.

A series of serendipitous events then occurred while photographing *Oases*. I noticed the stars shimmering in a desert pool late one evening as I hiked home from a shoot and I began to wonder how I might be able to capture this image. *Reflection Study* is the first successful photograph I created in the pursuit of this task, and it was exposed on a moonless night.

Shortly after, I was shooting another image of star reflections and, not wanting the ambient light from the moon to ruin my exposure, I closed the shutter as the moon climbed high in the sky. As I packed my camera in the dark, the glare of the moon on the pool's surface repeatedly caught my eye. With hesitation, I decided to set the camera back up. Struggling to focus the 5 × 4 camera in the dark, I chose a moderate aperture to ensure decent focus. *Moonstruck* changed the way I approach night photography, and I readily incorporated the moon into my ongoing project *Ethereal Days*.

Photographing at night is ripe with technical challenges: assuring proper focus in the dark, achieving correct exposure without the aid of a meter, anticipating the path of heavenly bodies and their participation in the composition and investing a whole night for one or two sheets of film are among them. Despite these challenges, I continue to learn and improvise. I am excited to delve more deeply into the genre of night photography and I'm looking forward to more evenings camped beneath the ether.

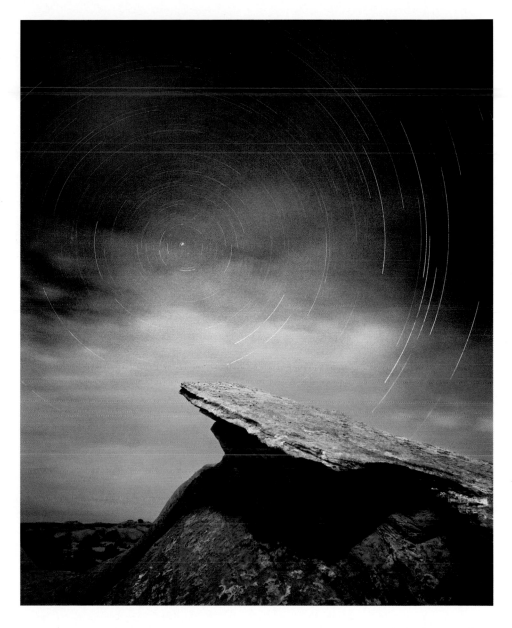

Northern Sky by Chris Conrad

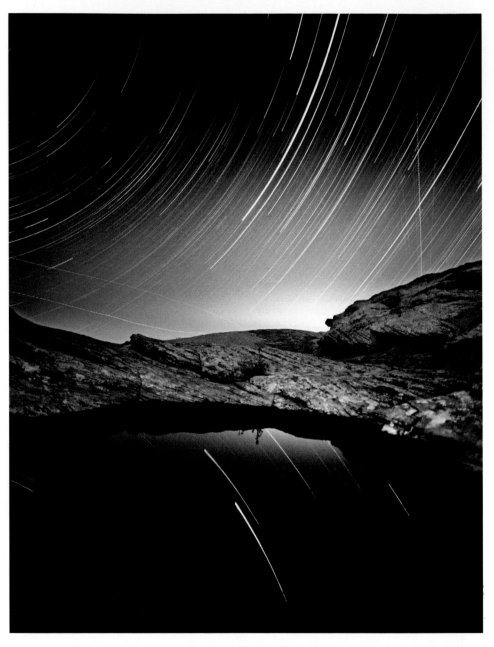

Making masks

Chris writes: Once I have properly exposed a negative, I hand-process the film using either a normal, plus, or minus development, and then I usually move into a digital workflow. Scanning my film for its intended print size, I use either Nikon or Epson scanners. The Nikons work extremely well for 35mm and medium-format film; the Epson V750 handles all sizes up to 8 × 10in. While one can spend far more money on film scanners, I have found that careful handling of film and a clean working space yield excellent results from these moderately priced machines.

Once I have my image scanned, I use what I call neo-traditional techniques in Adobe Photoshop. I've had a basic introduction to darkroom printing, so I understand burning and dodging, as well as multi-contrast printing. With these techniques in mind, I create custom layer masks to be used with the Curves tool in Photoshop.

Using masks allows me to apply custom burning, dodging, or local contrast to any area of the photograph. One can make extremely complex masks to match horizon lines, specific objects and more in the computer. Photoshop allows a user to save, retouch, and make infinite adjustments to the contrast within each mask.

To make the final prints, I have used several black and white ink sets including Lyson, MIS Associates, plus Sundance Septone. While all of these products produced acceptable results, once I tried a software called Quad Tone RIP, I was hooked. QTR may not be as versatile as the Sundance Septone system I used extensively for about two years, but its use of colour inks in my Epson printers to make stunning black and white images makes it my new favourite output software. I can now use my Epson 7600 and 2200 printers to make both colour and greyscale prints with the same inks.

Reflection Study by Chris Conrad

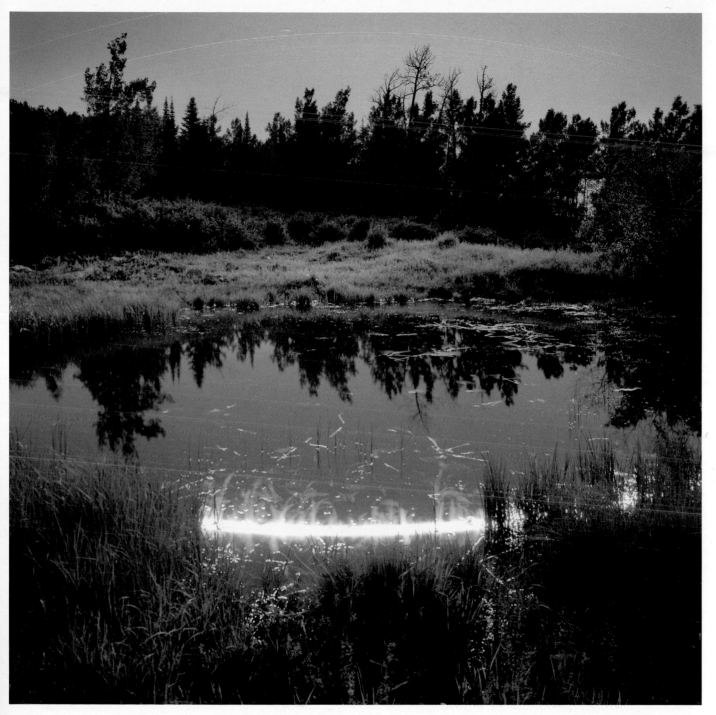

Summer Solstice by Chris Conrad

Seven:
The Final Image

\#

Sequencing. Websites. Proposals. Exhibitions.

Use a quality mount for your transparencies.

IMAGE CONTENT IS THE MOST IMPORTANT RESULT in photography, be it traditional black and white, colour film (positive or negative) or digital output. If an image is visually weak, no amount of after-exposure alteration will be able to save it. Proper exposure, strong and interesting composition and high-quality printing will all combine to make a powerful photograph.

After all these steps have been successfully completed, the final closure will come with presentation. There are many variations of this technique, all depending on what the final image is and how the photographer wants to present it.

If the final result is transparencies for stock sales – for submission to publishers of calendars, as one example – a quality mount of some kind should be used. For medium and large format transparencies this will best be achieved by having a printer make some kind of window mount of a standard size (a size that will fit into an easily available box), with the photographer's information nicely printed across the bottom of the matte. This will include the business name, mailing address, phone number and perhaps an email contact.

The colour of the matte material will be up to the photographer, but it should accent the photos. A bright colour will detract, drawing attention away from the transparency. Unless the transparencies are square, both horizontal and vertical mattes will need to be printed. While the actual interior and exterior dimensions will be the same, the printing will need to reflect the image orientation. Printers are able to cut a standard matte size with precision and the sleeved positive will be taped to the back of the matte. This presentation looks professional when laid out on a light table, much better than a pile of unmounted slides.

The presentation of 35mm slides is important, and the standard mounts that most labs use do not look professional. Remounting them in a sturdy plastic mount with glass protecting the photo is a decent alternative. The sealed mounts should be used for when editors make their first cut, pulling selected photos from the page. This way, the film is protected when the slide is removed.

As with larger formats, the mount should contain all contact information. There are many programs available that will print title labels (every photo should have a complete title), and keep track of when photos are out, which client has them, when they were returned and what the sales history is for every slide.

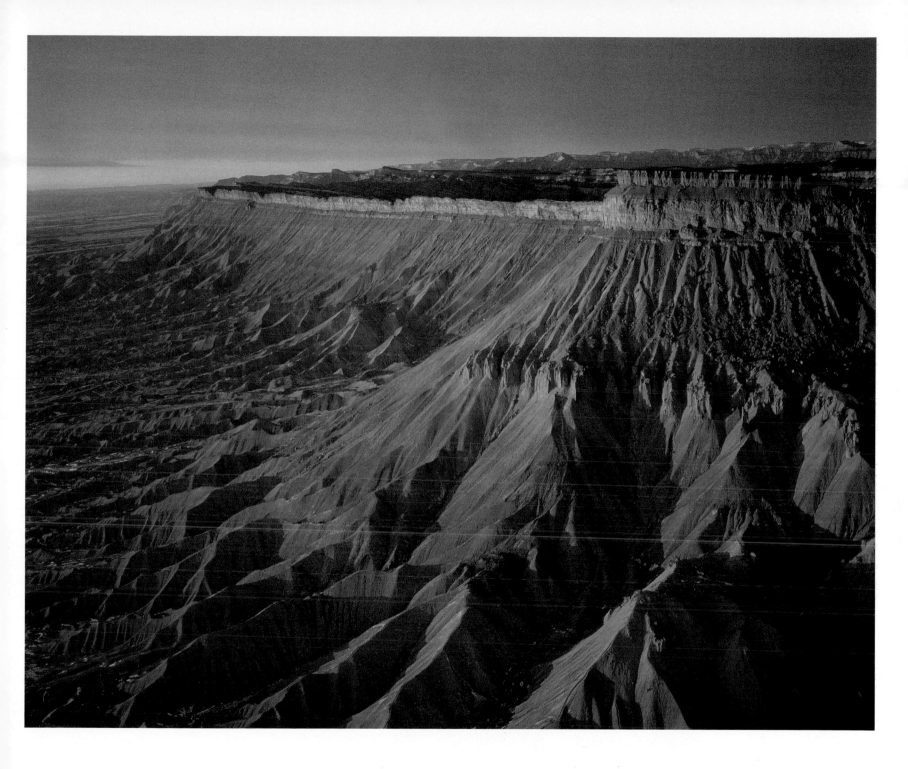

Different Media

There are myriad media available for making photographic prints, but some will provide a much higher level of quality than others. The choice will depend heavily on the photographer's desired effect, on whatever style of imagery is being practiced and on the hoped-for end result.

Traditional black and white is time consuming and requires a darkroom. There are few monochromatic approaches available, however, that are able to match a lovingly crafted silver print. With the recent rapid advances in digital monochromatic printing, as well as the influx of quality papers, this process is improving, and seems to be supplanting silver as the technique of choice. The layering of different inks can give a rich depth to these prints, and a quality job resembles the old style of platinum printing, with a long, smooth tonal scale imbedded in the paper's surface. This method also produces wonderful notecards and these are an excellent form of self-promotion.

There are several methodologies available to produce colour prints but few can reach a high level of quality. Ilfochrome paper (which used to be called Cibachrome) will give a print with vibrant colour, but contrast can be a problem. Many transparencies need to be masked, a technique that brings highlight densities down in the final print. This is a time-consuming process. This paper is only available in a high-gloss finish, which won't work well with every image.

Colour ink jet printing has made quantum strides recently and the papers are improving rapidly. This type of print, when laid down on a quality matte surface paper, has a wonderful depth and richness of palette. A major advantage of this style of printing is the contrast control available through Photoshop. A person who is experienced in this technique of preparation and printing will be able to produce a quality print from any original, be it scanned film or digital capture.

Shrimp boat
Traditional black and white printing is time consuming but rewarding.

Ink jet printer
One of many printers available today.

Print Presentation

When a print is the final product of this process, as the old adage says, presentation will be the icing on the cake. Whether the image is black and white or colour, certain guidelines will help reach the desired end.

A backing must be used to give support to the print and as a surface for the overmatte to adhere to. There are several methods available to mount the print onto the backboard, including using corners to hold the image, pressure papers to stick it onto the board and hot-press tissue used with a mount press. Leaving a reveal around the edge of the photo, a space of either plain paper or – if the print was trimmed to the image edge – an exposed lining of backboard, will improve the appearance of the mounted photograph, also leaving a convenient space for a signature.

The colour of the board will be up to the photographer, but again it should be subtle. An off-white board works well with monochromatic images and will often enhance colour prints as well. Pure white board is very stark in appearance and is often too bright for most photographs. Subtle hues of mount board, carefully matched to the dominant colours in the photo, will often accentuate a colour print.

Title, number and date are traditionally written on the back, with the signature on the bottom right of the front reveal. If the print is part of a limited edition, the numbers – both of that photo and the total edition number – are written on the bottom left of the opening below the photo.

Framing will be the last step and will require some thought. Thin black metal frames are a current favourite with photo galleries. When a frame is thin, but has some depth, the image will float within this boundary. This is a strong effect and will enhance the presentation of most photographs. For strongly toned black and white prints, a plain, thin wooden frame will occasionally work, usually of a lighter colour, tending towards blonde. Coloured frames will, in rare circumstances, combine effectively with a colour print, but usually they will detract from the image.

BELOW LEFT
My preferred style of frame.

BELOW RIGHT
An off-white board works well with monochromatic images.

The Final Image 159

Sequencing Images

Placing a series of photographs in a sequence that will offer continuity to the viewer requires thought, patience and perseverance. This will apply no matter what the final result, be it for an exhibition, a portfolio presentation or a book.

There needs to be a common underlying theme to build the sequence upon, and this may be obvious or subtle. Place is one theme that will give a strong base to a collection of images, but it will take time to build a strong group of photographs. Revisiting a particular area over time – always exploring with an open mind towards imagery – will gradually help build a strong portfolio. Almost any commonality will bind a portfolio together and sometimes the thread running through the grouping can be obscure. Another potential theme is reflections, one that opens the door to huge possibilities.

After a body of work has been collected, the actual ordering begins. By laying prints out in a row, and then altering the order until images begin to balance with each other, a final sequence will gradually appear. In addition to achieving harmony with the images adjacent to each other, a strong overall flow needs to be developed. There are different approaches and one school of thought involves beginning with details and ending with far views. Arranging shapes and hues in a complementary sequence is another approach while a black and white ordering might depend on a certain series of different contrasts.

Intuition will play a large part in sequencing and the feeling that 'this just works' will often come into play. The order of a series of images will be as important as the single photographs, in some cases even more so.

Pictures with a Theme: Reflections

Any central theme – either obvious or subtle – can hold a series of photos together. Reflections abound in the natural world and this is a topic that I have explored extensively in colour. This theme runs across a wide spectrum, ranging from a small compositional element to the main subject. By taking advantage of the wide colour spectrum that exists within reflections, and by using discriminate cropping when composing the image, this subject matter offers boundless possibilities. Combining this palette with both linear and non-linear shapes that are often being reflected will enhance the possibilities that are inherent within most reflections.

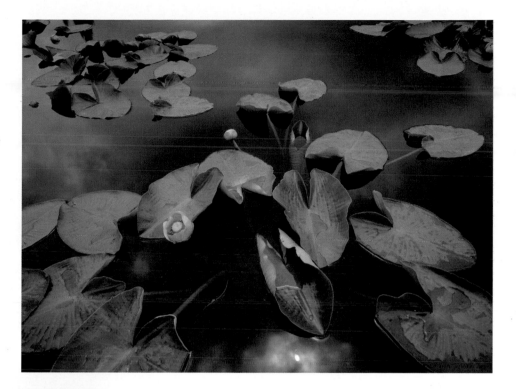

Cypress, Bayou Des Glaises,
Atachafalaya National Refuge,
Louisiana

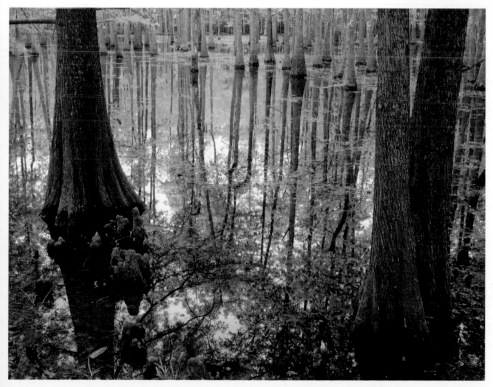

Pond, Grand Mesa,
Colorado

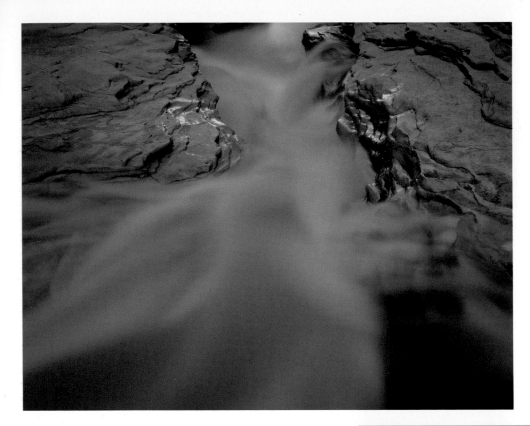

*Driftwood, Colorado River,
Cataract Canyon, Canyonlands
National Park, Utah*

*Indian Creek Canyon, Canyonlands
National Park, Utah*

Mount Garfield, Mesa County,
Colorado

Driftwood, Missouri River,
Ponca State Park, Dixon County,
Nebraska

Pictures with a Theme: Wildflowers

Wildflowers explode every spring in the natural world, and this showy display, while often short-lived, can offer wonderful photo opportunities. One common method of sequencing a subject like this is to begin with close-ups, gradually pulling away to more distant views. This is an obvious subject, but one that is always popular.

Blue Columbine, Poverty Gulch,
Gunnison National Forest,
Colorado

Yellow Sweet Clover, C.M. Russell
National Wildlife Refuge, Fergus
County, Montana

OPPOSITE
Blazingstar, Missouri River,
Nebraksa

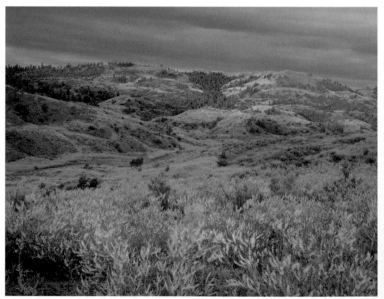

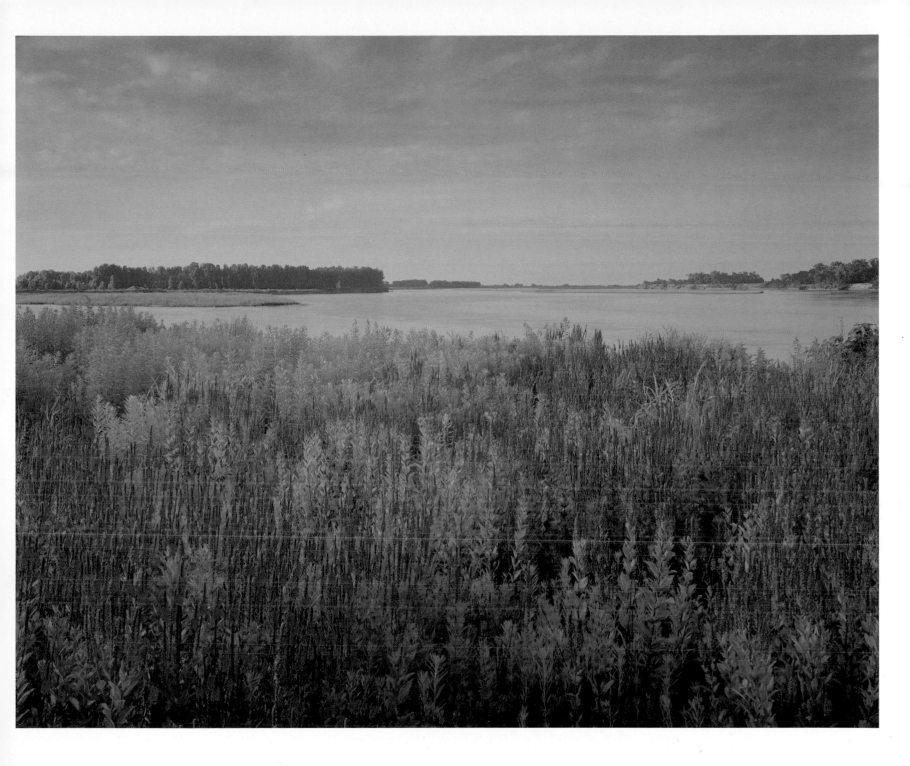

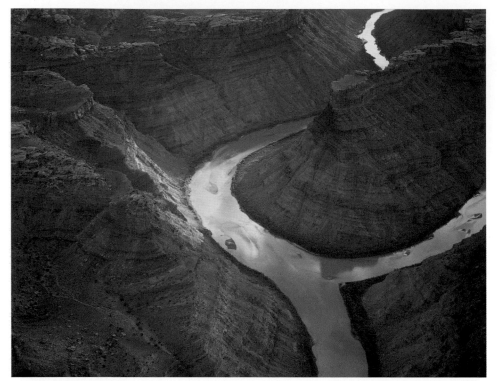

Pictures with a Theme: Aerials

For me, photography is about finding new and unusual views of the natural world, about seeking out rarely seen angles. Several years ago, in an effort to find new perspectives, I began doing aerial photography. Being hundreds of feet above your subject changes the most basic technical and visual aspects of composition, but it also offers an unusual and often vibrant view of the natural landscape.

Confluence, Canyonlands National Park, Utah

Druid Arch, Canyonlands National Park, Utah

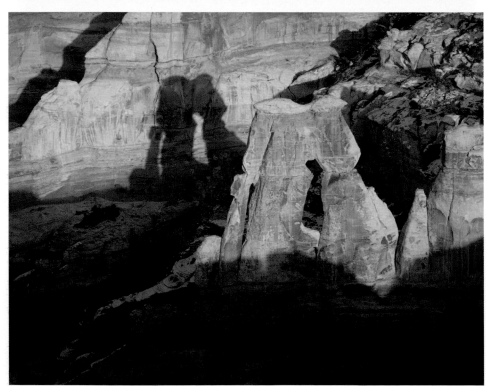

OPPOSITE
Behind the Rocks, Grand County, Utah

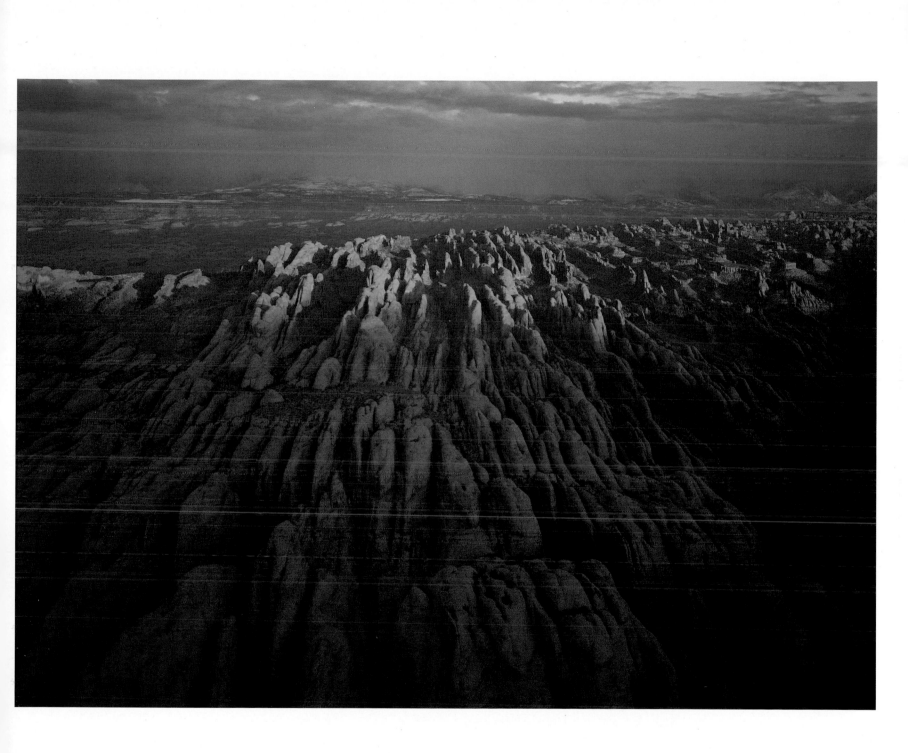

On the web
**Having a website is a relatively
cheap way to display your work.**

Websites

Having a personal website is important, especially for
a professional photographer. Even amateur shooters
should make use of this, as it is a relatively cheap way
to display work. There are several important steps to
setting up a site, and the initial one is design. Having a
clean and interesting design, from the opening page to
the closing, will improve a site.

The second important aspect is the scans. Having
high quality scans made will save trouble later in the
process, as the image quality needs to be high. The third
step is arranging the different sections and sequencing
the photos in each area. As mentioned in the previous
paragraphs, the order of photos on a site will be very
important. Having a haphazard mix of images will
detract, and a visitor's interest will wane.

Hiring a professional web designer is pricey, but will
reward the photographer in the long run. Having a poor
site will hurt your future prospects.

There are many group photo sites where a
membership fee allows for a certain number of images
to be displayed. This is far less expensive than a
personal site and will still offer the photographer a
good venue to display work.

Book Proposals

The best method to submit a book proposal to a publisher is to create a mock-up of your idea, and the strongest presentation available is a leather-bound digital hardcover. Printing out the photos and text and carefully sequencing the images will make a clean, impressive presentation. There are several companies that produce a nice leather-bound cover, with high quality interior pages, complete with some type of mounting system.

Book ideas
Here are three book proposals I have put together, one depicting a deserted island off the west coast of Mexico, and two centred around photos taken with toy cameras.

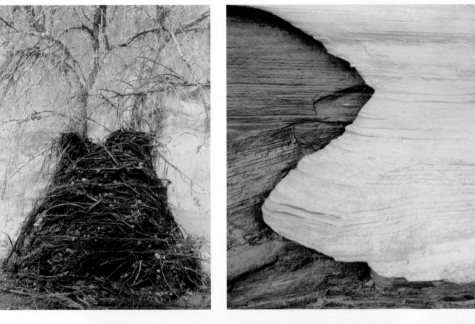

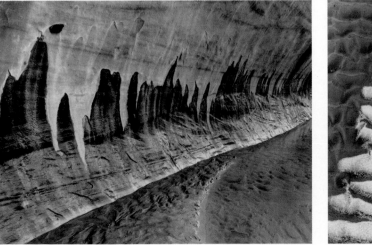

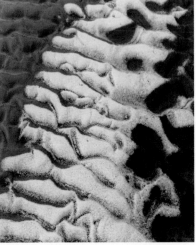

Courthouse Wash, Utah
These images are part of a collection of pictures for a book proposal on Courthouse Wash.

Septone Cards

It can be very difficult to get your work out for people to see and the available avenues for this are limited. One recent method I have been using is to print small runs of notecards. In the past, a small print run meant having a thousand cards made, and quality printing is very expensive. A recent digital process, however, has made the manufacture of quality cards both accessible and relatively inexpensive.

The Septone process uses an Epson printer and a seven-ink system. Three inks are different shades of warm grey, three are different shades of cool grey, and the final ink is black. By shifting the balance between these inks, and because so much ink is laid on the paper, a very lush tonal range is available. This process gives a very nice reproduction of a silver print, and pre-folded notecards are available from several digital paper companies.

My scanner and printer is Chris Conrad at petroscans.com, and he has become very adept at reproducing my photographs with the Septone process. These cards, considering their high quality, are fairly inexpensive, and they offer the great advantage of limited runs. I will generally have Chris make ten cards from a new image, deciding later if the photo warrants more cards.

We have also begun using this system to make book proposals, and I have put two together, both printed with Septone, and bound in good leather covers.

These cards have been generating interest lately, and I have made several sales to major photo museums and bookstores. They have also opened many doors for me, including an upcoming exhibition at a major gallery. Short of sending original prints to people, this is the best way to show your work to publishers and galleries.

Presentation
Here are several digital notecards and a book proposal on Courthouse Wash, Utah, a canyon that I have photographed for more than twenty years.

Mounting an Exhibition

The final aim for the process is presentation and there are several means to this end. Printed matter – books, cards, calendars, etc – is a strong way to present your work and will ensure that people actually see it. There are several paper companies manufacturing pre-folded notecard stock, and this is a good way to show work.

Another method of displaying work is to hang an exhibition, and presentation and sequencing have a heavy influence here. These photos are from my last show, at a lovely gallery in my home town. Brian Parkin and Marian Boardley opened Moab Art Works in 2007 and invited me to put up a black and white show.

Brian and I started with 35 prints and, after sequencing and allocating wall space, winnowed them down to 20 final images. The final framing, arrangement and general presentation were excellent and it was one of the best exhibitions I have been involved in.

Exhibition
Opening night at the Moab Art Works exhibition, with me standing next to the Four Yeibeichai print (see page 53). This framing and matting method is my favourite style of presentation, especially for monochrome prints.

Conclusion

The sheer number of philosophies and guidelines involved in composition are dizzying, and can be enough to give a permanent distaste for the whole process. Hopefully, this book has offered a clear approach, and has made it obvious that the entire subject is up for serious personal interpretation. Intuition has been frequently mentioned, and in this photographer's opinion it is an underused and under appreciated aspect of the whole process.

Compositional ability – a unique and personal view of the world – is a trait that can easily be developed, through both thought and practice. Personal philosophies, both about imagery and the world in general, will play a huge part in this development.

The litmus test for any composition is repeated viewing over an extended period of time. After the initial reaction to an image has passed, a gradual, almost subconscious process begins, slowly revealing the true strengths and weaknesses of the photograph. Scenes that seemed strong at first exposure will often fade, while quiet images will gain in power as time passes.

It is difficult to break down such an esoteric process, but if this text has aided the reader with creating a personally meaningful portfolio, then I will count it a success.

Palmetto, Long Pine Key,
Everglades National Park, Florida

Glossary

APERTURE the size of the opening through which light passes through the camera or enlarger lens. It is controlled by an adjustable diaphragm.

BURNING selectively darkening an area of the print by giving additional exposure after the main enlarger exposure.

CAMERA MOVEMENTS the various adjustments on a large-format camera which permit the relative positions of film and lens to be altered, giving control over perspective and depth of field.

DEPTH OF FIELD the distance between the nearest and furthest elements in the image which appear in sharp focus.

DODGING selectively lightening part of a print by shading it from the light source during enlargement.

EXPOSURE the process of taking a photograph by admitting light to the film; also the amount of light admitted, which is governed by the combination of aperture and shutter speed.

F-STOP the unit in which lens apertures are measured. Each whole step in the f-stop sequence represents a doubling or halving of the amount of light admitted.

FIELD CAMERA a large-format camera of the traditional type, with a hinged baseboard, often made of wood.

FILTER a tinted or otherwise treated piece of glass or gelatin which alters the character of light passing through the camera or enlarger lens, usually to adjust the contrast of the image.

GRADED PAPER photographic paper supplied in a choice of grades, each providing a different level of contrast.

ISO RATING the standard measure of film sensitivity, specified by the International Standards Organization.

LARGE-FORMAT CAMERA one which uses single sheets rather than rolls of film, most commonly in the 4 x 5in format.

LIGHT METER a device, either built into the camera or made separately, for measuring the light falling on or reflected from the subject, in order to permit accurate exposure.

MEDIUM-FORMAT CAMERA one that uses rolls of film with opaque paper backing, nearly always in the 120 format, giving negative sizes from 6 x 4.5 to 6 x 9cm.

RECIPROCITY the principle by which a one-stop change in aperture can be compensated by a one-stop change in shutter speed and vice versa, so that overall exposure remains unchanged. At exposures longer than 1 second, reciprocity failure occurs, and exposure time must be increased.

SHUTTER the mechanism by which light is admitted through the camera lens for a precisely measured length of time.

SPLIT-CONTRAST PRINTING the method of printing which involves separate enlarger exposures at hard and soft contrast settings.

ZONE SYSTEM way of calculating exposure to ensure shadows, highlights and midtones appear as desired.

Index

Photo captions are indicated by page numbers in **bold**.

Monterey Cypress, Pescadero Point, Del Monte Forest, California

photographers'
pip
institute press

To request a full catalogue of Photographers'
Institute Press titles, please contact:
GMC Publications, Castle Place, 166 High Street,
Lewes, East Sussex BN7 1XN, United Kingdom
TEL: 01273 488005 FAX: 01273 402866
www.pipress.com